Norman Rockwell
332 MAGAZINE COVERS

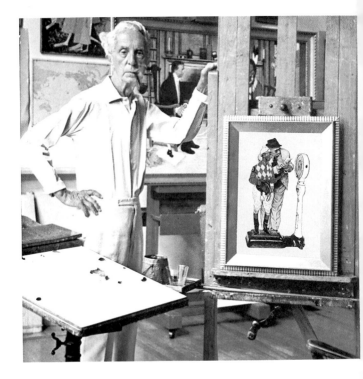

CHRISTOPHER FINCH

Norman Rockwell
332 MAGAZINE COVERS

A Tiny Folio ™
ABBEVILLE PRESS PUBLISHERS
New York London

Library of Congress Cataloging-in-Publication Data
Finch, Christopher.
 Norman Rockwell—332 magazine covers/
by Christopher Finch. p. cm.
 ISBN 978-0-7892-0409-7
 1. Rockwell, Norman, 1894–1978.
 2. Magazine covers—United States. I. Title.
 NC975.5.R62A4 1990
 741.6′52′092—dc20 89-18435

First hardcover Tiny Folio™ edition
15 14 13 12

For bulk and premium sales and for text adoption procedures, write to Customer Service
Manager, Abbeville Press, 137 Varick Street, New York, NY 10013 or call 1-800-ARTBOOK.

Visit Abbeville Press online at www.abbeville.com.

CONTENTS

Norman Rockwell Portrayed Americans as Americans Chose to See Themselves

NORMAN ROCKWELL began his career as an illustrator in 1910, the year that Mark Twain died. He sold his first cover paintings when there were still horse-drawn cabs on the streets of many American cities, and he began his association with *The Saturday Evening Post* in 1916, the year in which Woodrow Wilson was elected to a second term in the White House and the year in which Chaplin's movie *The Floorwalker* broke box-office records across the country. Young women were enjoying the comparative freedom of ankle-length skirts, and their beaux were sere-nading them with such immortal ditties as "The Sunshine of Your Smile" and "Yackie Hacki Wicki Wackie Woo". In literature this was the age of Booth Tarkington, Edith Wharton, and O. Henry. Ernest Hemingway, still in his teens, was a cub reporter for the *Kansas City Star,* and F. Scott Fitzgerald—soon to become a frequent contributor to the *Post*—was still at Princeton. The New York Armory Show of 1913 had introduced the American public to recent trends in European paint-ing, but traditional values still reigned supreme in the American art world. Only a handful of artists aspired to anything more novel than the mild postimpressionism of painters like John Sloan and Maurice

Prendergast. The movies were becoming a potent force in popular entertainment, but few people took them seriously or thought they might one day take their place alongside established art forms.

It was a world in transition, but the transition had not yet accelerated to the giddy speed it would achieve in the twenties. People could be thrilled by the exploits of pioneer aviators without being conscious of the impact that flying machines would have on modern warfare. It was possible to enjoy the conveniences provided by such relatively new inventions as the telephone, the phonograph, the vacuum cleaner, and the automobile without being too troubled by the notion that technology might some day soon threaten the established order of things.

The illustrator and cover artist working in the mid-teens of the twentieth century was generally asked to embody established values. The latest model Hupmobile Runabout might well be the subject of a given picture—an advertisement, perhaps—but the people who were shown admiring or driving in the newfangled vehicle were presumed to espouse the same values as their parents and their grandparents. The set of the jaw, the glint in the eye had not changed much since the middle of the nineteenth century. The women wore their hair a little differently, perhaps, and men were doing without beards, but these were superficial differences. The fact is that the minds of the people who edited and bought magazines like *Colliers, Country Gentleman, Literary Digest,* and *The Saturday Evening Post* had been formed, to a large extent, in the Victorian era.

Norman Rockwell himself, born on the Upper West Side of

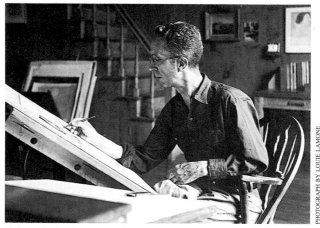

Norman Rockwell at work in his studio in Stockbridge, Massachusetts.

Manhattan, had a classic late Victorian upbringing. He spent his childhood in a solidly middle-class, God-fearing household in which it was the custom for his father to read the works of Dickens out loud to the entire family. Thus Rockwell had little difficulty in adapting to the conventions that were current in the field of magazine illustration at the outset of his career. Although a New Yorker, he was especially drawn to rural subject matter (he is on record as saying that he felt more at home in the country). This reinforced his affection for traditional idioms, since

it focused his attention on the most conservative elements of the population, those who were least susceptible to change of any kind.

In short, Rockwell began his career right in the mainstream of the illustrators of his day, sharing the assumptions and concerns of his contemporaries and of the editors who employed him. His work is remarkable because he sustained through half a century the values that he espoused in those early days when the world was changing more drastically than anyone could have imagined possible. It would be easy enough, of course, to find fault with his refusal to break with those values, but that would be unjust. Rockwell simply continued to believe in what he had always believed in, and in his own way, he did, in fact, change and grow throughout his career. He learned how to embrace the modern age without abandoning his own principles. But he was also forced to modify and enrich his approach to the art of illustration in order to reconcile those principles to a world that was evolving so fast it seemed, at times, on the verge of flying apart.

His earliest paintings are conventional, almost to the point of banality, because the values they embody could be taken so much for granted. As he was forced to deal with a changing environment, however, he was obliged to become more inventive and original. A situation that could be presented in the simplest of terms in 1916, for example, might still be valid a quarter of a century later, but only if it were made more specific. Stereotypes had to be replaced by carefully individualized characters. More and more detail had to be introduced to make a situation more particular. As time passed, Rockwell was called upon to draw on all his

resources as an illustrator in order to pull his audience—which was always changing—along with him. As circumstances became, theoretically at least, more hostile to his kind of traditional image-making, he rose to the challenge. His work became richer and more resonant, reaching a peak in the forties and fifties when most of the men who had been his rivals at the outset of his career were already long forgotten. His most remarkable quality was his ability to grow and adapt—to remain flexible—without ever modifying the basic tenets of his art.

What seems to have enabled him to do this was a belief in the fundamental decency of the great majority of his fellow human beings. This belief was the most deep-seated of all his values, and it enabled him to perceive a continuity in behavior patterns undisturbed by shifts in social mores. The twentieth century has offered plenty of evidence of man's ability to shed his humanity, and Rockwell was certainly aware of this, yet he clung to his belief in decency. It was an article of faith, and it gave his work its particular flavor of innocence.

Over the past hundred years or so, artists and critics have been ambiguous in their attitudes toward innocence. The "naïve" vision of such painters as Henri Rousseau has been much prized, yet more schooled artists have often been led astray when they attempted to embrace such a vision (indeed it would be difficult for such a vision to survive schooling). Picasso, the most protean of all twentieth-century artists—greatly admired by Rockwell, it should be noted—was able to run the full gamut: from a childlike delight in transforming bicycle parts into the likeness of a bull's head to the nightmare vision of

Guernica—but Picasso was, in every way, an exception to the rules.

Rockwell's art has nothing, of course, to do with the innovations of modern painting. He was essentially a popular artist—an entertainer—and he was always fully aware that his work was intended to be seen in reproduction. The originals—generally painted on a relatively large scale—are, however, beautiful objects in their own right. He was looking to the general public rather than to a small, highly informed audience, and it was this perhaps that enabled him to sustain the innocence of his vision. Dealing with mass communication rather than the higher reaches of aesthetic decision-making, he has no place in the developing pattern of art history. It is futile even to compare him with American realists like Edward Hopper, whose subject matter occasionally had something in common with Rockwell's. Hopper was always concerned primarily with plastic values, as is the case with any "pure" painter. Rockwell, on the other hand, had to think first and foremost about conveying information about his subject, as must be the case with any illustrator. An illustrator may, of course, have many of the same skills as the "pure" painter, but he deploys them in a different way. Essentially he borrows from existing idioms of easel painting—whether traditional, as in Norman Rockwell's case, or more experimental, as was the case with his notable contemporary Rockwell Kent—and uses them as a means of conveying information. Interestingly, it is known that Norman Rockwell himself, during the twenties, was drawn to modern idioms—the result of a sojourn in Paris—but rejected them in favor of older conventions. The reason for this, we may suppose, was his recognition of the fact that

his gift was not painterly at all (remarkable as his painterly skills were). It was, rather, his ability as a pictorial storyteller.

Most of Rockwell's finest covers are, in effect, anecdotes. With occasional exceptions, he can give us only one scene—an isolated episode—but, in his mature work especially, he knows how to pack that scene with so much significant detail that the events that precede it, and follow from it, are, so to speak, latent in the single image. A great short story writer, like Guy de Maupassant, can conjure up a whole life within the span of a dozen pages. Rockwell, at his best, was capable of doing the same kind of thing with a single picture. Because of this he deserves to be thought of as something more than *just* an illustrator. An illustrator, by definition, is someone who takes another person's story (or advertising copy) and adds a visual dimension. Rockwell, in his cover art, went far beyond this. He was not only the illustrator, but also the author of the story. In his work, image and anecdote were inseparable; each sprang naturally from the other.

It is perhaps easier to find parallels for Rockwell in the world of literature than in the world of painting. His world is full of echoes of Dickens and Twain, and he has much in common with O. Henry. It seems to me, though, that the writer Rockwell most resembles—despite enormous differences in cultural background—is P. G. Wodehouse, another perennial contributor to *The Saturday Evening Post* and Rockwell's senior by eleven years.

Wodehouse was, of course, as quintessentially English as Rockwell was American. It's worth noting, though, that Wodehouse—a long-

time United States resident—always kept his vast American readership in mind, peppering his stories with Americanisms that were far from current in his native country at the time. H. L. Mencken credited him with introducing many Anglicisms into the American vocabulary. But while this was undoubtedly the case, he was far more successful in causing his English readers to adopt American slang. What the two have in common, along with being gentle humorists and master storytellers, is a basic innocence of concept allied with tremendous technical skill. Wodehouse succeeded in placing his protagonists in a kind of Arcadian never-never land, a fabulous environment that bore a recognizable resemblance to the real world but was somehow different, drained of malice. His cast of characters—Jeeves, Bertie, Psmith, Lord Emsworth and the Mulliner clan, along with assorted debutantes (both bird-brained and spunky), regulars of the bar-parlour at the Anglers' Rest, and the various Hooray Henrys who keep the leather chairs in the Drones Club polished with the backsides of their Saville Row suits—were drawn from the conventional repertory of English upper-class and upper-middle-class types (always, of course, provided with a supporting cast of dour domestics, canny rustics, and impoverished clerics). It is the way he handled them, however, that is significant. Evelyn Waugh, for example, drew on many of the same prototypes for his own acid brand of satire, treating them—in his early novels—as grotesque puppets. Wodehouse, for his part, transformed them into bumbling nymphs and fauns cakewalking their way through a sylvan landscape in which temporary embarrassments—dotty aunts,

13

imagined rivals, and stolen pigs—take on cosmic significance. In Wodehouse's world, a loss of timing on the golf links is as near as anyone comes to having an existential experience. It is a world innocent of original sin, and hence of real guilt. In the hands of a lesser technician, it would be merely ludicrous, but Wodehouse was such a superb wordsmith—his narrative and dialogue always strike just the right note—that we are able to accept every absurd turn of events as being part of the natural order of things.

Rockwell's skill with a paintbrush was a match for Wodehouse's deftness with a turn of phrase. Rockwell drew on American stock characters, just as Wodehouse drew on the British repertory, and—again like Wodehouse—placed them in a world free of malice. It's true that Rockwell found it harder to ignore happenings in the real world—as is clear in his wartime covers—but always he saw things in terms of the small crises of everyday life. Rockwell's protagonists come from backgrounds very different from those that produced Wodehouse's characters, but they have the same basic innocence. We might say that both men were genuinely incapable of perceiving evil, or at least of permitting it to intrude into their work. They represented worlds that may never have existed (though most of us wish they could have), and they made them believable.

Both, in short, created utopias—utopias that are all the more agreeable for being so modest, so unpretentious. Of the two, Wodehouse's was the more self-contained. Since most of his stories were set in a world the great majority of his readers were unfamiliar with—the world

of English country houses and titled cadgers—he could, so to speak, draw his own boundaries. To be sure, he occasionally sent his protagonists to Manhattan or Hollywood, but even there they wandered blithely through funhouse settings peopled with improbably sentimental gangsters and movie moguls of unsullied stupidity. Rockwell, on the other hand, created a more open-ended utopia, since, nominally at least, it was based on the world that his audience lived in. This was reinforced by the fact that he worked in an industry where it was established practice for cover artists to submit ideas to publishers for approval before proceeding with the finished work. Magazine publishers, needless to say, were not unconscious of circulation figures and hence tended to reinforce the cover artist's desire to remain in tune with his audience.

Rockwell never seems to have had much trouble sustaining such a rapport. His utopia and that of his audience were, to all intents and purposes, the same thing. He portrayed Americans as they chose to see themselves. It is easier to recognize this in his earlier covers—those painted prior to the late thirties, say—because, with few exceptions, they make no pretense at being anything but stylized representations of situations, amusing or touching, that play some more or less clever variation on an archetypal theme—the vagaries of young love, the compensation of old age, and so forth. We've met the characters who people these situations in the stories of Mark Twain and a thousand lesser writers (many of them published by *The Saturday Evening Post*). Rockwell brought to these stereotypes a crispness of vision and, within the limits set by the conventions he adhered to, a subtlety of characterization.

15

Generally, in the first two decades of his career, the protagonists of his little dramas are portrayed with the minimum of props necessary to tell the story, silhouetted against a white background, the latter designed to accommodate and exploit the expansive magazine logos in style at the time. (More than was the case in his later career, Rockwell was obliged to be a designer as well as an illustrator. The two-dimensional blend of image and logo was at least as important as the treatment of the subject matter. It was this combination that made the individual cover stand out on the newsstand and sold magazines.) The figures in these earlier paintings are familiar icons, isolated from the context of the everyday world. As time passed, however, Rockwell became increasingly skillful at suggesting a broader context through the imaginative use of props.

As early as 1930 a documentary note crept into Rockwell's covers once in a while. (In "Gary Cooper" he brings a gentle irony to the subject of a he-man movie star being made up for his role in a western.) By the late thirties this note was evident more and more often. When the *Post* changed its logo in 1942, Rockwell was ready to take advantage of this by coming up with a new approach to cover art: his protagonists were placed in detailed settings that themselves helped tell the story or gave us information about the subjects' lifestyles. Increasingly his work took on a documentary appearance. These were real people, the reader could tell himself, in a real setting—and often enough this was literally true.

Rockwell had always drawn from life, and from 1937 on, he made extensive use of photography as an aid to capturing naturalistic poses. These were frequently real people—his family, friends, neighbors—

16

and often the settings, too, were places that were familiar to him—houses, streets, and landscapes that were part of his everyday world.

Early examples of Rockwell's mature technique (which might be described as "fictional" documentary, or synthetic documentary) are to be found in the Willie Gillis covers, a series that Rockwell painted between October 1941 and October 1946. Rockwell was concerned in those covers with portraying the plight of "an ordinary inoffensive little guy thrown into the chaos of war." At the time he was looking for a suitable model for his Gillis, Rockwell was attending a square dance in Vermont; there he spotted a young man named Robert Buck who he thought would be exactly right. Even better, from a practical point of view, Buck was supposedly unfit for military duty; he would thus be available to pose for as many covers as Rockwell might care to paint around that particular character. After Rockwell had painted five Gillis covers, however, Buck succeeded in passing his physical and was inducted into the service, leaving Rockwell with the predicament of having invented a popular character—one who was making his quiet contribution to morale on the home front—but no model to paint him from. Rockwell hit on the solution of devising scenes in which the photographic likeness of Buck/Gillis could be used to stand in for the flesh and blood character. After the war, when Buck came back home, Rockwell used him as a live model once more, winding the series up with a portrayal of Willie's return to civilian life.

The impression of this sequence of covers was that of a documentary portrait of one young man's progress from the period immediately

before Pearl Harbor to the period after V-J Day. In fact, of course, Willie Gillis was entirely a figment of Norman Rockwell's imagination—a symbolic protagonist designed to serve a specific purpose at a specific time. If there is anything atypical of Rockwell's career in this, it is only the notion of using a single character over an extended period of time—a device that enabled Willie to come to seem like someone that everyone had known. The way in which a kind of synthetic "reality" was created—through the agency of the illustrator's imagination—from models, photographs, and sketches was, however, entirely characteristic of the kind of approach Rockwell would utilize throughout the latter part of his career.

Generally, then, each of Rockwell's protagonists is called upon just once, to grace a single cover. We encounter each one like a figure chanced upon in a snapshot that has been selected almost at random from some family album. Yet, in the later work, all the images seem somehow connected. They belong to the same world. The young couple portrayed in "Marriage License" might well move into one of the houses we see in the background of "Commuters." It is easy to imagine that the counterman we are shown in "After the Prom" has his hair cut on the premises presented in "Shuffleton's Barber Shop." As we study Rockwell's covers—especially since the late thirties—we begin to feel that every image interlocks with a half dozen others. In a sense they are all part of one massive work. Each takes on a greater significance because of those that have preceded it and those that will follow it. As has been remarked, Rockwell enriched his work by making his

vision more explicit as time went by, but time itself enriched it by bringing the sum of his previous achievements to bear on each new painting. We should not judge Rockwell by any individual work, nor even by a selection of his finest pictures, but rather by the cumulative effect of his total output. It is this that makes Rockwell so outstanding a figure in the pantheon of American popular culture.

Elsewhere I have remarked that it seems, at first glance, almost absurd to talk of Norman Rockwell as having a distinctive style—his stock in trade is quasi-photographic realism, and his technique derives from a variety of conventional academic sources—yet a Rockwell painting is immediately recognizable as a Rockwell painting. Clearly he does have a style that is unlike any other. It is not easy to define, however, because it does not depend upon any broad mannerisms. It is, rather, made up of small but significant deviations from the photographic and academic norms.

One thing that we will discover if we study Rockwell's work carefully is that the best of his early works are, in general, more "painterly" than most of his later canvases, though these later canvases tended to make more successful covers. When I speak of certain early works as being "painterly," I mean that they are conceived and executed more as conventional easel paintings, whereas the later works often have the look of tinted drawings (even though they are executed in oil paint on canvas). This difference should not be taken as a hard and fast rule, but it does represent a significant tendency, as a few examples will show.

If we turn to the 1921 cover "No Swimming," we find that it has

been painted in an almost impressionistic way. There is no question here of an outline having been drawn then filled in with color. On the contrary, the image is built up from areas of boldly applied pigment—a well-loaded brush is evident—overlapping and overlaying each other to build up planes that create the illusion of solidity and depth. (Note in particular the way in which the anatomy of the boy in the foreground has been evoked.) Many of the edges of forms have been deliberately blurred in this picture, partly to help produce a sense of speed, but largely as a natural consequence of this approach to image-making. Even Rockwell's highly stylized signature is loosely painted. Turning to the 1930 cover "Gary Cooper," we find a composition that is less impressionistic but equally painterly. Again it is built up from carefully placed and orchestrated patches of pigment that add up to the kind of plastic presentation of an image that would win the approval of the most academic of easel painters.

Later examples of Rockwell's cover art often show a very different approach. The 1946 cover painting "New York Central Diner" is a clear instance of the dominance of drawing over painting. The dining car itself has been evoked with little more than a few lines, many of them estab-lished with the help of a ruler, and everywhere—even in the figures—the outline is dominant. Within these outlines the minimum of modeling is used to produce an illusion of depth and solidity. Again the signature is symbolic of the overall approach: Rockwell has left in the guidelines that ordinarily he would have painted out. If we look at a sixties cover like "The Window Washer," we see how clearly the finished painting is pre-

figured in the preliminary drawing. In many such instances, in fact, the work that appeared on the cover of the *Post* was little more than a drawing transferred onto canvas and heightened with color.

Often, in his later work, Rockwell uses a rather artificial kind of texture to give the illusion of painterliness to what is, in fact, a tinted drawing. In particular, he is fond of a very deliberate kind of impasto (physical buildup of pigment), often applying it in what seems at first glance like a wholly inappropriate way, as for example in his treatment of the mirror in "Triple Self Portrait." An extreme example of the application of this technique occurs in the 1946 cover "Commuters." This is a composition governed almost entirely by carefully drawn outlines, but practically the entire area of the canvas has been further enlivened through the use of thickly textured underpainting—roofs, platforms, hillside are all given variations of texture—and clearly this was no accident. Rockwell used this device because he knew that it reproduced well.

As the years passed, Rockwell learned to use any trick of the trade that would lend itself to reproduction and hence contribute to the impact of the cover itself. Correspondingly, he became less and less concerned with what was correct from a strictly academic point of view. He realized, in short, that he was not going to be judged as a conventional easel painter. Again and again he would tell people, "I am not an artist. I am an illustrator."

Rockwell's facility was such that he was equally at home whether he was emphasizing the painterly aspects of his skills or demonstrating his virtuosity as a draftsman. It seems to me, in fact, that his finest work generally came about when he achieved some kind of balance between two

approaches, as happened from time to time throughout his career, especially in the forties and fifties. To see this, we might look at four of his most successful canvases: "Shuffleton's Barber Shop," "Solitaire," "Breaking Home Ties," and "The Marriage License."

In "Shuffleton's Barber Shop" everything is clearly defined in terms of outlines—we sense the drawing beneath the paint surface—yet there are wonderful painterly touches, such as the atmospheric suggestion of the reflections in the window at the rear of the shop. It is almost as if Rockwell has tried to capture the spirit of the chamber music that is being played in the back room, as if he were searching for an exact blend of line and timbre, of melody and harmony.

In the case of "Solitaire," too, we sense that a careful pencil study has been transferred to the canvas. But here Rockwell seems to have been carried away—delightfully so—by the textures and colors of the seedy hotel room. The carpet and the wallpaper have been conjured up with a splendid fluidity of brushwork. The gaudy necktie draped in the foreground is like a miniature abstract painting in itself.

"Breaking Home Ties" is perhaps the most painterly of all Rockwell's mature covers—it may just be the finest painting he ever did—but even here the draftsmanship is far more in evidence than in, for example, an early masterpiece like "No Swimming." "The Marriage License," painted just a few months after "Breaking Home Ties," does not display quite the same involvement with paint for its own sake, but still it is much more than just another tinted drawing. One suspects that Rockwell probably took this composition further than he had antici-

pated when he first painted it. The idea is rather conventional, but evidently it triggered something in Rockwell's imagination, and he brought more passion than usual to the painting, passion that is evident in the sheer richness of the pigment.

Rockwell was a master of many techniques, then, and he used whatever means was necessary to get across his point. Certain things, however, are constant in his work from the very beginning. There was, for example, something immediately recognizable about the way he assembled the "props" for his paintings. He was never afraid of making the most obvious choices, nor was he afraid of organizing them in the most obvious way. Turning to "Breaking Home Ties" once more, it is full of deliberate contrasts that are anything but subtle. To take just a single instance, notice the way the father's worn shoes have been pointedly contrasted with the son's shiny new ones. The word to describe this is—inescapably—"obvious." There is something obvious, too, about the little still life to the left of the picture, made up of the signalman's flag and lamp set down so conveniently on the black trunk. Almost every decision that has been made in this wonderful composition is, essentially, obvious. One suspects that nobody but Rockwell could have gotten away with this. Most artists affect us by surprising us. Rockwell affects us by giving us exactly what we expect. (This is not as easy as it sounds since probably we are unaware of just what it is we do expect until we are presented with it.) To bring the obvious to life is one of the most difficult things that an artist can attempt. Within the field of illustration, Rockwell was the great master of the obvious.

What makes a Rockwell a Rockwell—more even than in the use of "props"—is the way in which he presents faces and hands. "No Swimming" may be impressionistic, but the face and visible hand of the boy in the foreground has been painted with an intensity and an attention to detail that is not found elsewhere on the canvas, except in the face of the dog. You can take almost any Rockwell cover from any period and you will find that more care has been spent on the faces and hands than on anything else. These features give the composition its focal centers. In fact, one reason why many of the costume paintings fail is that, in those instances, Rockwell has sacrificed the emphasis on faces and hands to his interest in rendering fabrics and period folderols.

Occasionally Rockwell indulged in caricature, but more usually, when dealing with the face, he gave us a heightened naturalism that verged on caricature without quite crossing the line. He was particularly good at depicting family relationships as they are expressed in shared features. He had the knack of concentrating on those little physical similarities that often escape notice. If we look again at the father and son in "Breaking Home Ties," we can see exactly what Rockwell was capable of when faced with such similarities. The hands, too, in that painting are worth careful study. They are as expressive of family bonds as anything that Rockwell has found in the two faces.

Always, then, it is the little human touches that make Rockwell's paintings memorable. Without them, his brilliance as a storyteller could never have had quite the same ring of authenticity.

SATURDAY EVENING POST COVERS

May 20, 1916–June 28, 1919

Preceded by covers for COUNTRY GENTLEMAN, LITERARY DIGEST,
and LADIES' HOME JOURNAL, 1919–1928

From the Very Beginning Norman Rockwell Had an Uncanny Knack
of Knowing What the Public Wanted

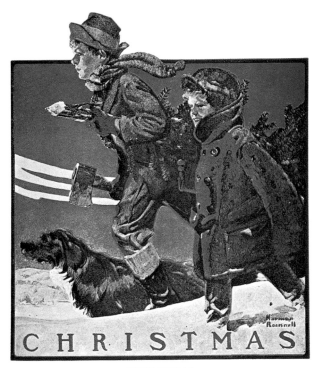

CHRISTMAS

Country Gentleman Cover • Dec. 18, 1920

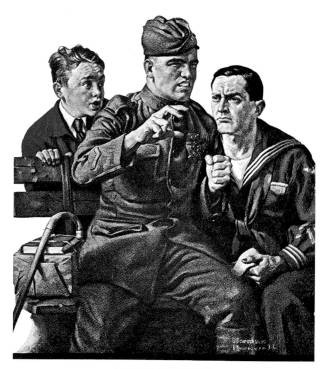

LOST BATTALION
Literary Digest Cover • March 1, 1919

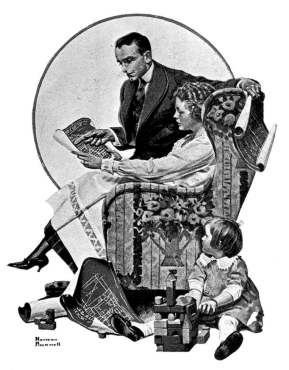

PLANNING THE HOME

Literary Digest Cover • May 8, 1920

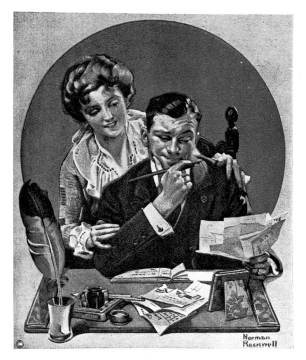

FIRST OF THE MONTH

Literary Digest Cover • February 26, 1921

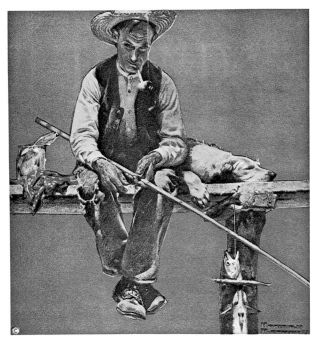

GONE FISHING

Literary Digest Cover • July 30, 1921

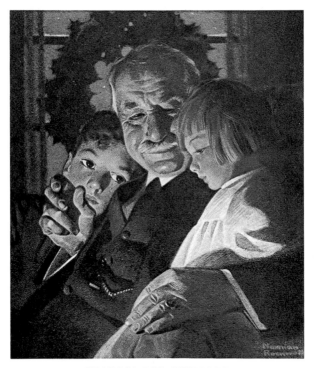

GRANDPA AND CHILDREN

Literary Digest Cover • December 24, 1921

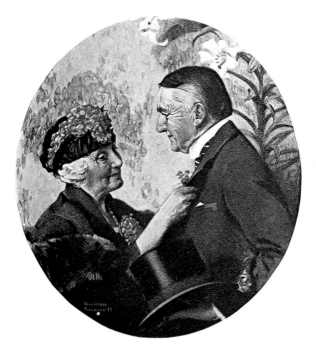

THE OLD COUPLE

Literary Digest Cover • April 15, 1922

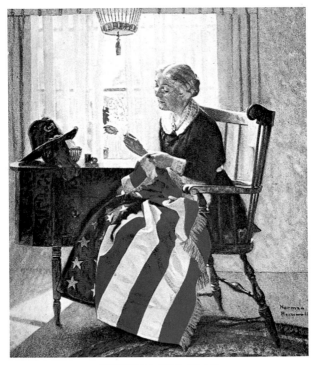

MENDING THE FLAG
Literary Digest Cover • *May 27, 1922*

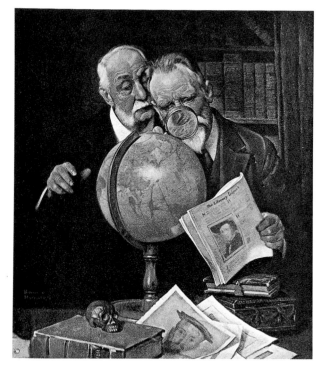

SETTLING AN ARGUMENT
Literary Digest Cover • June 24, 1922

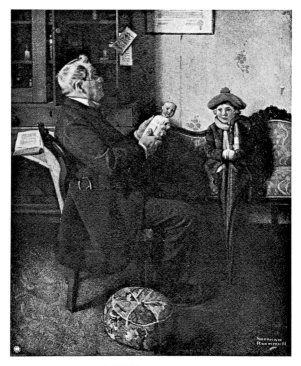

A HOPELESS CASE

Literary Digest Cover • January 13, 1923

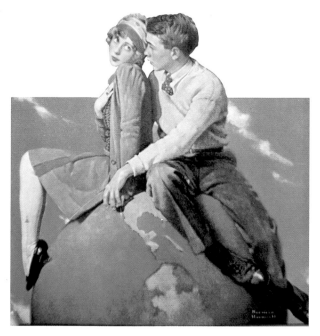

TOP OF THE WORLD

Ladies Home Journal Cover • April, 1928

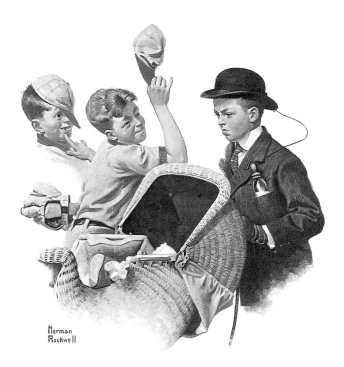

SALUTATION

Post Cover • May 20, 1916

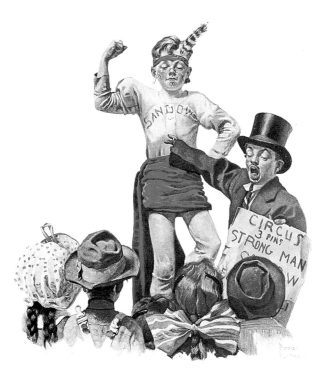

CIRCUS STRONGMAN
Post Cover • June 3, 1916

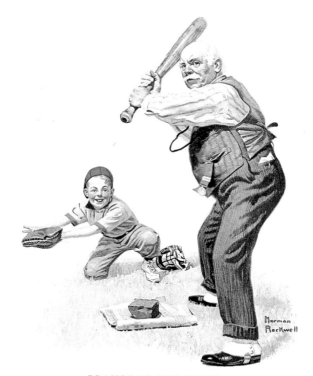

GRAMPS AT THE PLATE

Post Cover • August 5, 1916

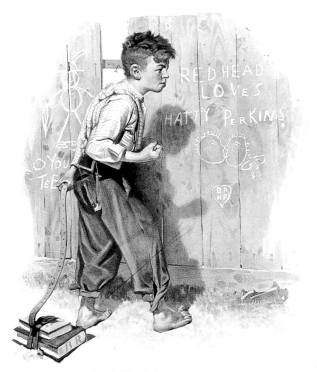

REDHEAD LOVES HATTY

Post Cover • September 16, 1916

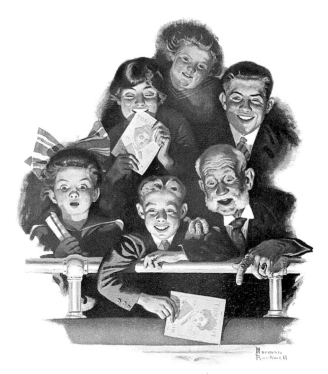

PICTURE PALACE

Post Cover • October 14, 1916

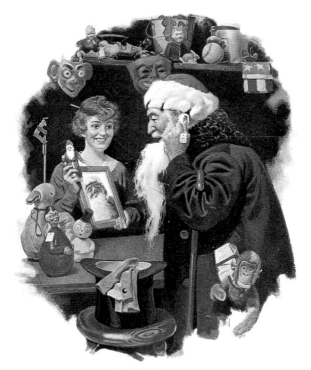

PLAYING SANTA

Post Cover • December 9, 1916

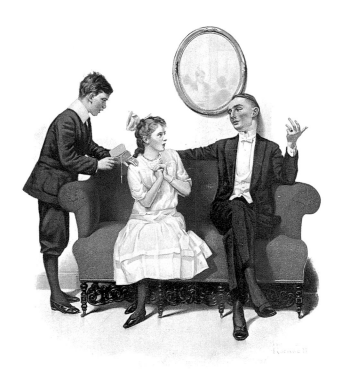

SHALL WE DANCE?

Post Cover • *January 13, 1917*

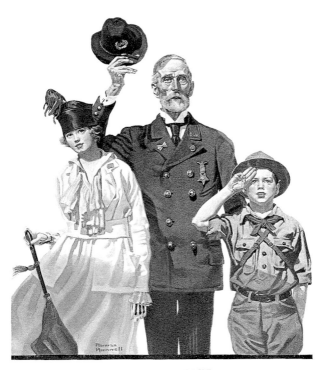

READY TO SERVE

Post Cover • May 12, 1917

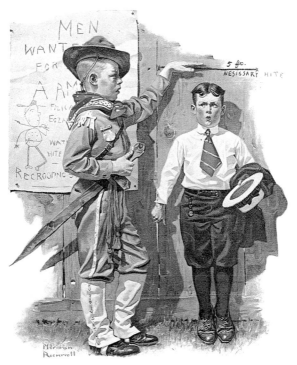

RECRUITING OFFICER

Post Cover • June 16, 1917

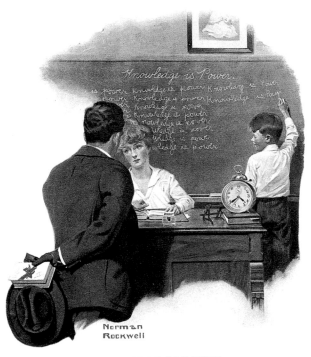

KNOWLEDGE IS POWER

Post Cover • October 27, 1917

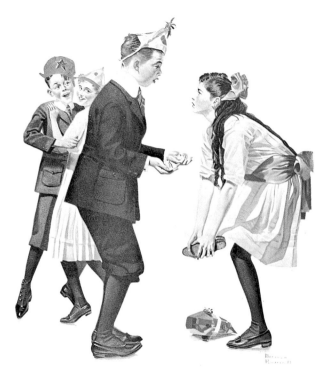

PARDON ME!

Post Cover • January 26, 1918

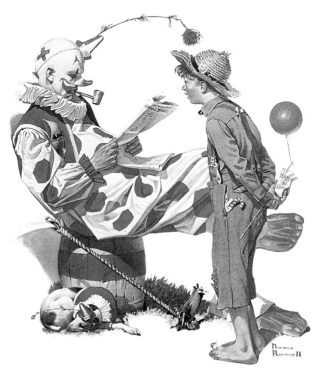

OFF-DUTY CLOWN

Post Cover • May 18, 1918

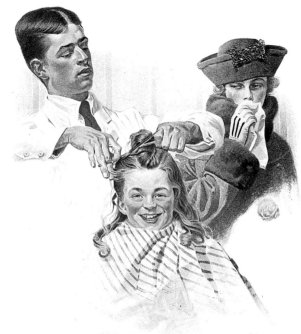

THE HAIRCUT

Post Cover • August 10, 1918

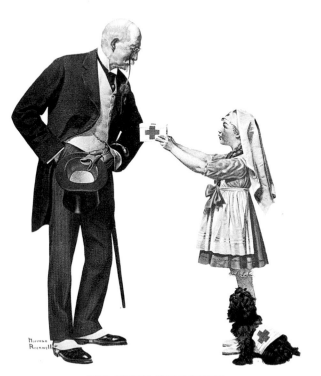

RED CROSS VOLUNTEER

Post Cover • September 21, 1918

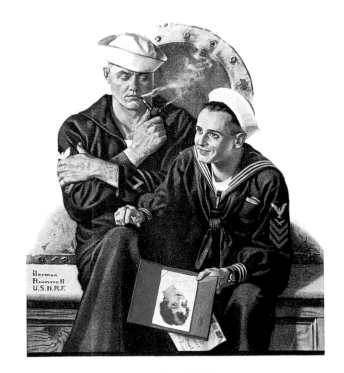

REMINISCING

Post Cover • January 18, 1919

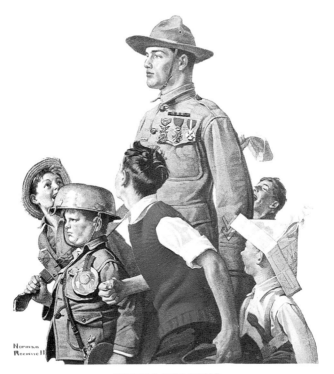

HERO'S WELCOME

Post Cover • February 22, 1919

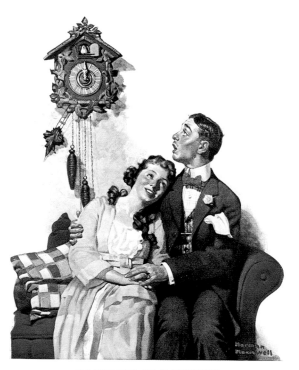

COURTING AT MIDNIGHT

Post Cover • March 22, 1919

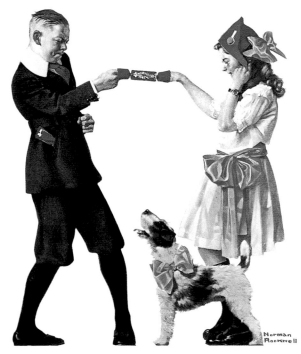

PARTY GAMES

Post Cover • April 26, 1919

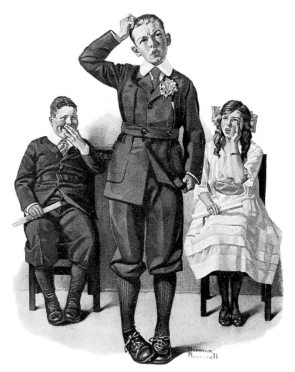

VALEDICTORIAN

Post Cover • June 14, 1919

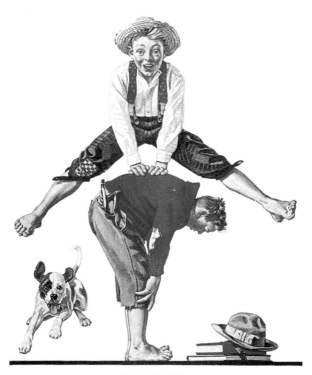

LEAPFROG

Post Cover • June 28, 1919

SATURDAY EVENING POST COVERS
August 9, 1919–September 9, 1922

Although Still Under Thirty Rockwell Was Rapidly Becoming
the *Post*'s Premier Cover Artist

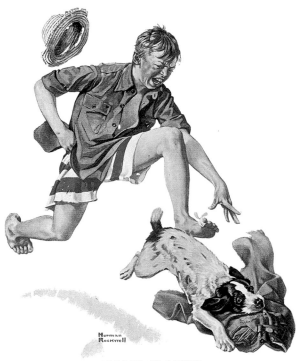

STOLEN CLOTHES

Post Cover • August 9, 1919

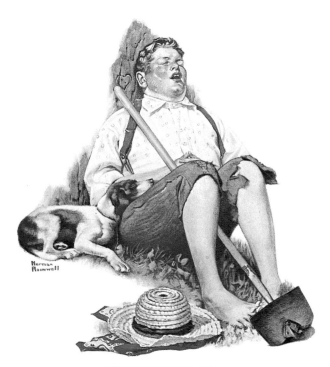

ASLEEP ON THE JOB

Post Cover • September 6, 1919

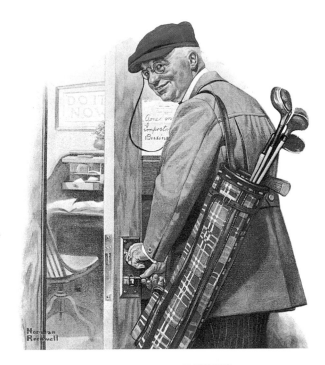

IMPORTANT BUSINESS

Post Cover • September 20, 1919

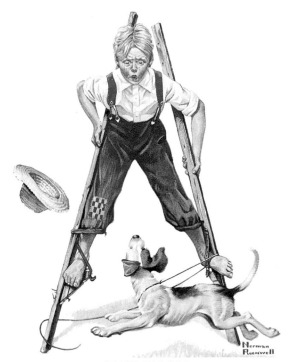

STILT WALKER

Post Cover • *October 4, 1919*

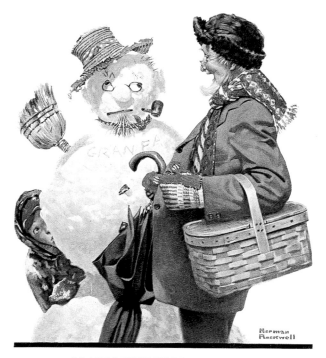

GRAMPS ENCOUNTERS GRAMPS!

Post Cover • December 20, 1919

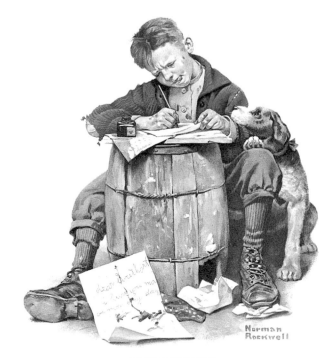

LOVE LETTERS

Post Cover • January 17, 1920

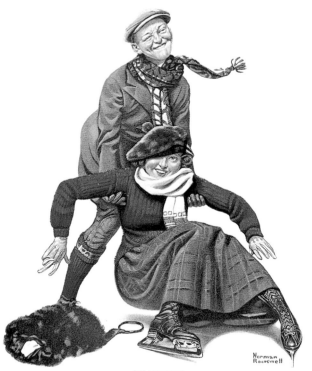

SKATERS

Post Cover • February 7, 1920

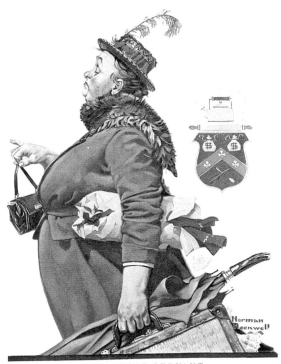

DEPARTING SERVANT

Post Cover • March 27, 1920

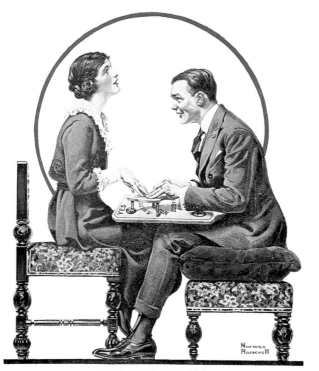

THE OUIJA BOARD

Post Cover • May 1, 1920

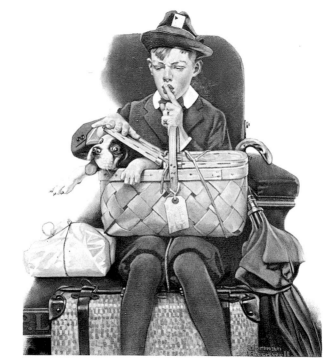

TRAVELLING COMPANIONS

Post Cover • May 15, 1920

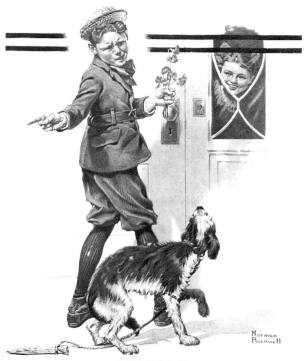

A DOG'S DAY

Post Cover • June 19, 1920

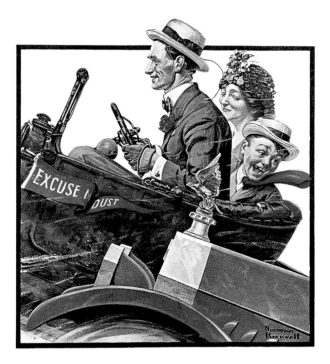

THE OPEN ROAD

Post Cover • July 31, 1920

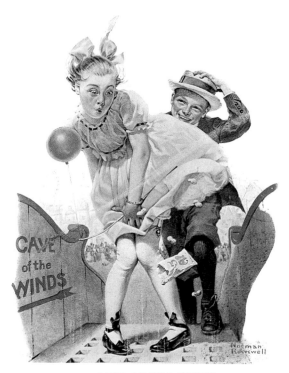

CAVE OF THE WINDS

Post Cover • August 28, 1920

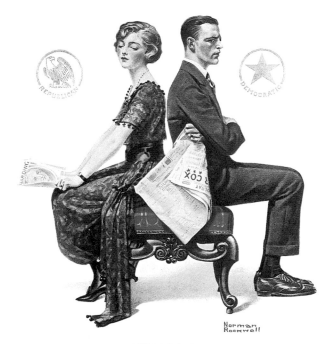

THE DEBATE
Post Cover • *October 9, 1920*

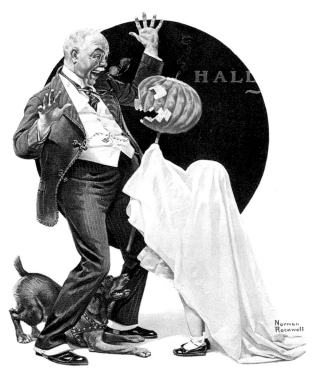

HALLOWE'EN
Post Cover • October 23, 1920

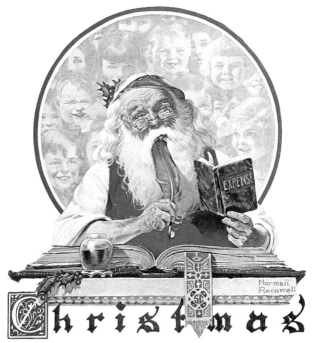

SANTA

Post Cover • December 4, 1920

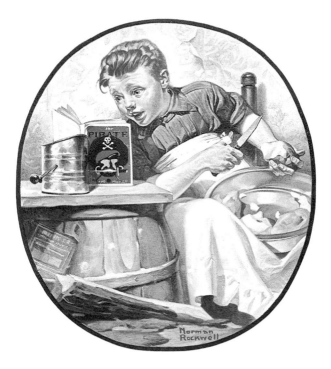

ON THE HIGH SEAS

Post Cover • January 29, 1921

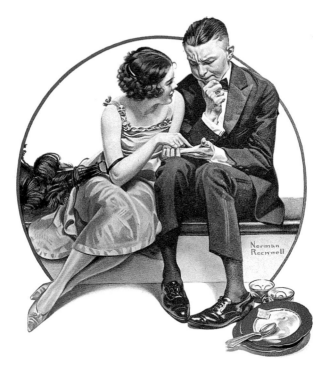

A NIGHT ON THE TOWN

Post Cover • March 12, 1921

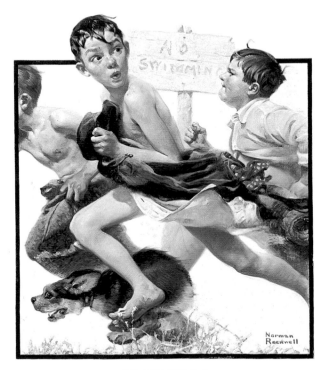

NO SWIMMING

Post Cover • June 4, 1921

WATCH THE BIRDIE

Post Cover • July 9, 1921

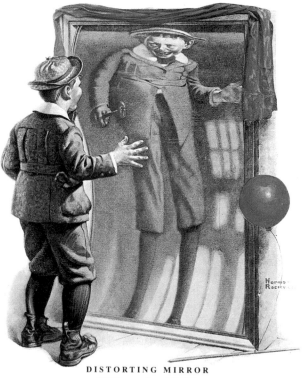

DISTORTING MIRROR

Post Cover • August 13, 1921

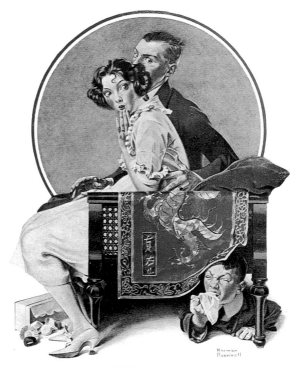

SNEEZING SPY

Post Cover • October 1, 1921

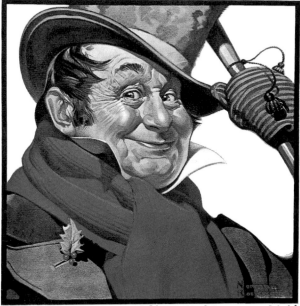

"Merrie Christmas!"

MERRIE CHRISTMAS

Post Cover • Dec. 3, 1921

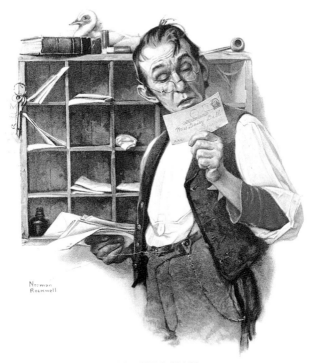

SORTING MAIL

Post Cover • February 18, 1922

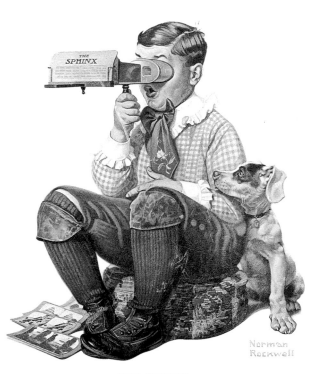

THE SPHINX

Post Cover • January 14, 1922

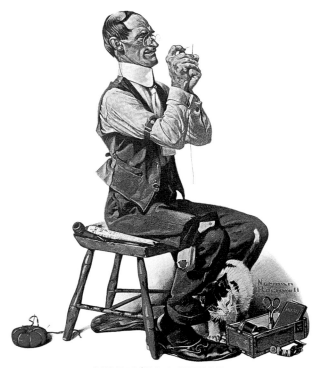

THREADING A NEEDLE

Post Cover • April 8, 1922

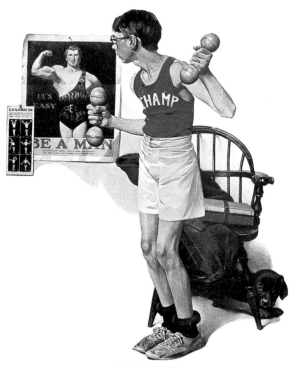

BE A MAN!

Post Cover • April 29, 1922

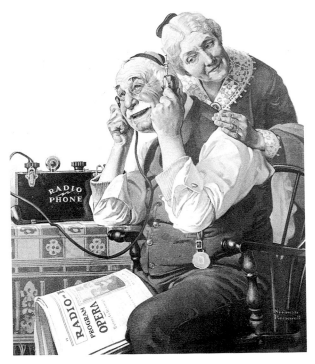

THE WONDERS OF RADIO

Post Cover • May 20, 1922

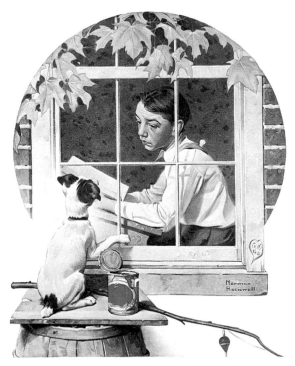

BOY GAZING OUT OF A WINDOW

Post Cover • *June 10, 1922*

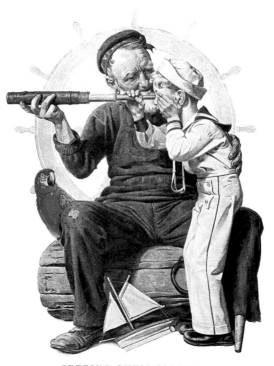

SETTING ONE'S SIGHTS

Post Cover • August 19, 1922

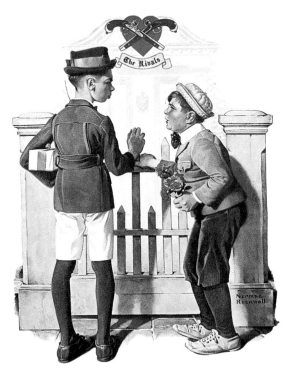

THE RIVALS

Post Cover • September 9, 1922

SATURDAY EVENING POST COVERS
November 4, 1922–December 5, 1925

———————◆———————

Things Were Changing Too Fast and Rockwell Gave People
Nostalgic Glimpses of the World They Had Left Behind

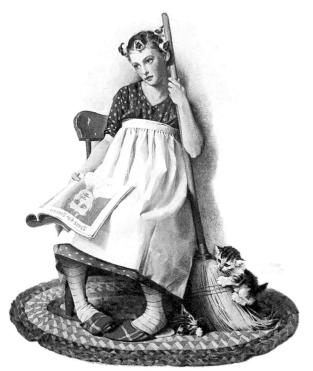

CINDERELLA

Post Cover • November 4, 1922

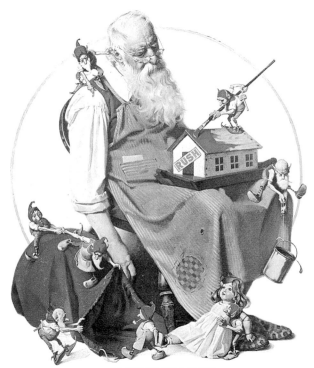

SANTA'S HELPERS

Post Cover • December 2, 1922

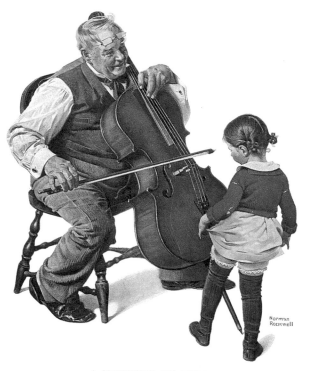

A MEETING OF MINDS

Post Cover • February 3, 1923

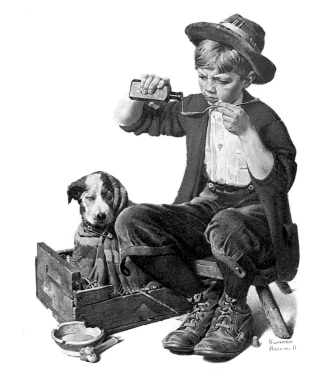

BEDSIDE MANNER

Post Cover • *March 10, 1923*

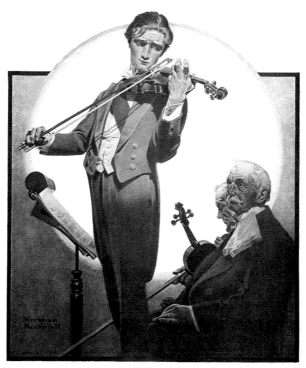

THE VIRTUOSO

Post Cover • April 28, 1923

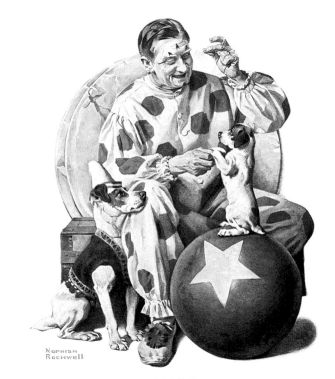

CLOWN
Post Cover • *May 26, 1923*

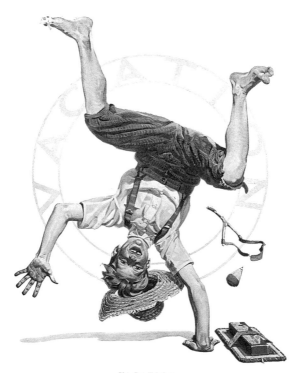

VACATION

Post Cover • June 23, 1923

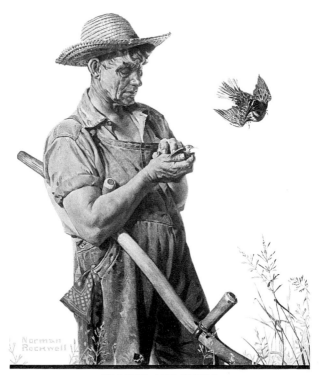

FARMER AND BIRDS

Post Cover • August 18, 1923

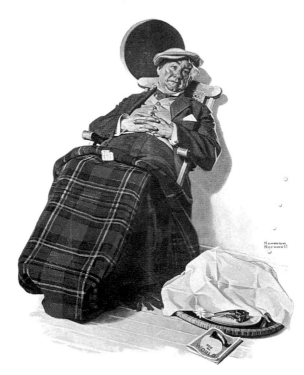

THE CRUISE

Post Cover • September 8, 1923

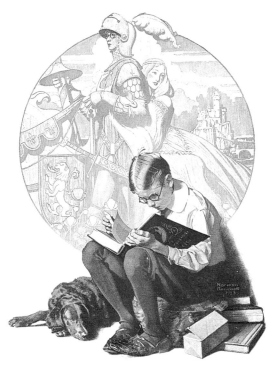

THE AGE OF ROMANCE

Post Cover • November 10, 1923

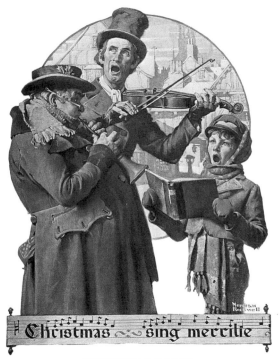

CHRISTMAS CAROL

Post Cover • December 8, 1923

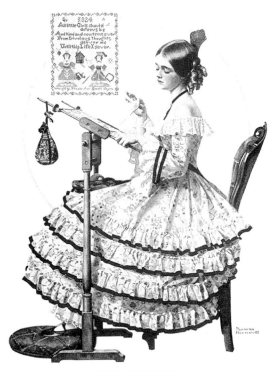

THE SAMPLER

Post Cover • March 1, 1924

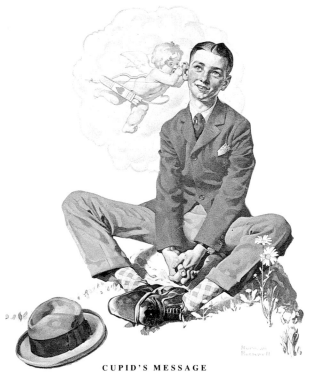

CUPID'S MESSAGE

Post Cover • April 5, 1924

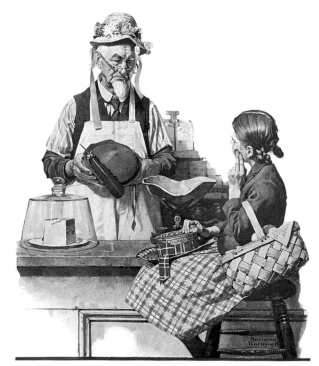

THE MODEL

Post Cover • May 3, 1924

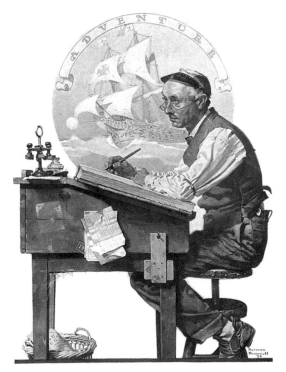

ADVENTURE

Post Cover • June 7, 1924

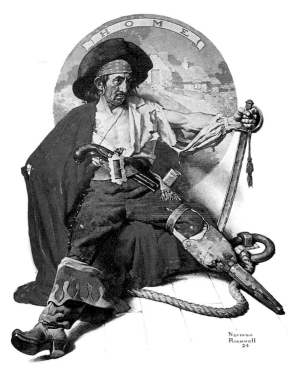

HOME

Post Cover • June 14, 1924

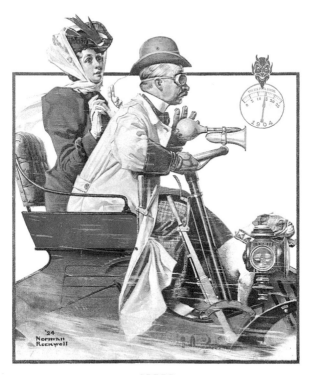

SPEED

Post Cover • July 19, 1924

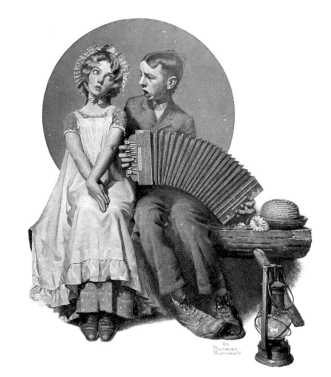

THE ACCORDIONIST

Post Cover • August 30, 1924

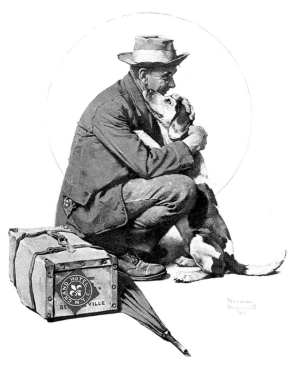

HOMECOMING

Post Cover • *September 27, 1924*

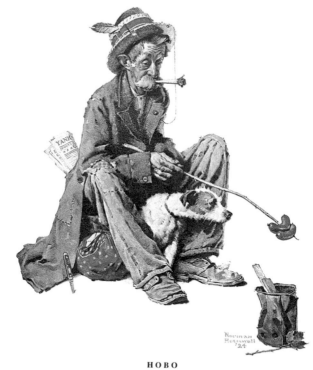

HOBO

Post Cover • October 18, 1924

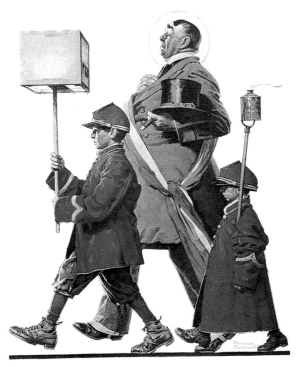

CEREMONIAL GARB

Post Cover • November 8, 1924

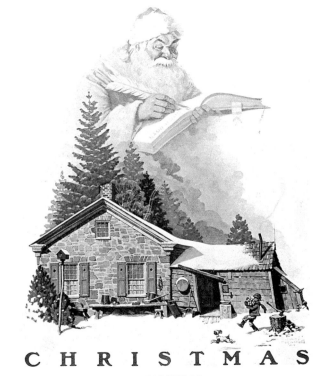

C H R I S T M A S

CHRISTMAS
Post Cover • December 6, 1924

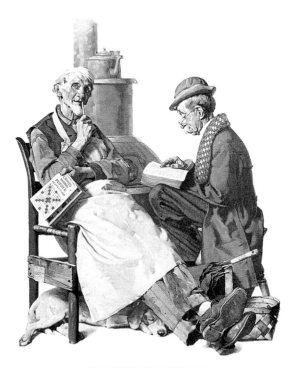

CROSSWORD PUZZLE

Post Cover • January 31, 1925

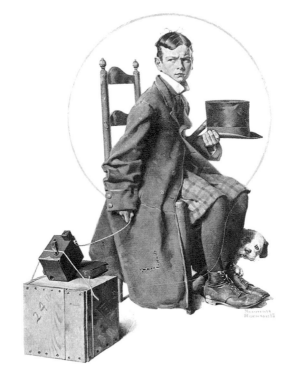

SELF-PORTRAIT

Post Cover • April 18, 1925

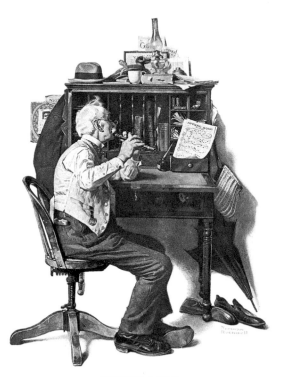

SPRING SONG

Post Cover • May 16, 1925

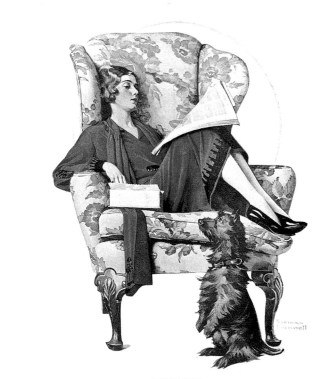

BEGGING

Post Cover • June 27, 1925

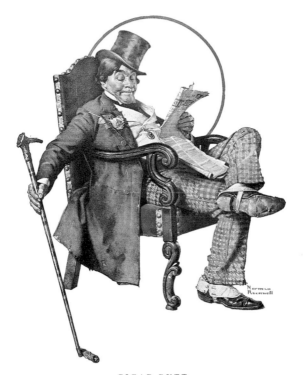

CIGAR BUTT

Post Cover • July 11, 1925

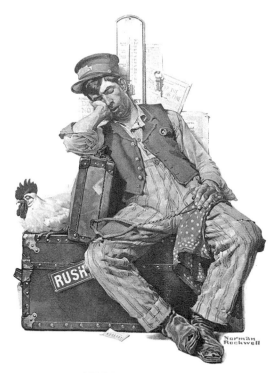

ASLEEP ON THE JOB

Post Cover • August 29, 1925

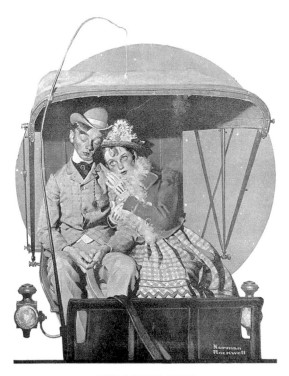

THE BUGGY RIDE

Post Cover • September 19, 1925

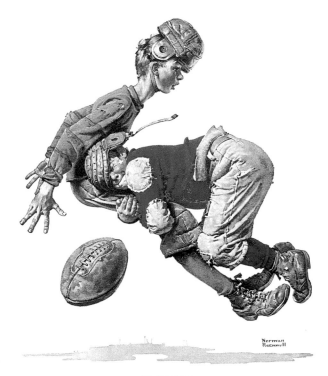

TACKLED

Post Cover • November 21, 1925

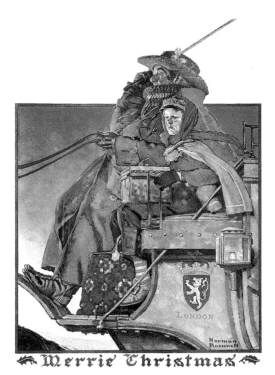

Merrie Christmas

MERRIE CHRISTMAS

Post Cover • December 5, 1925

SATURDAY EVENING POST COVERS
January 9, 1926–February 16, 1929

Again and Again Rockwell Fell Back on Tried and Tested Themes

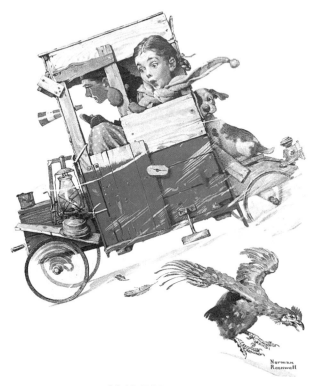

SOAP BOX RACER

Post Cover • January 9, 1926

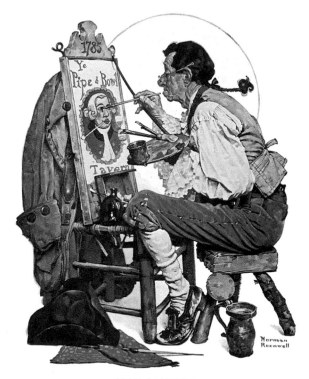

SIGN PAINTER

Post Cover • February 6, 1926

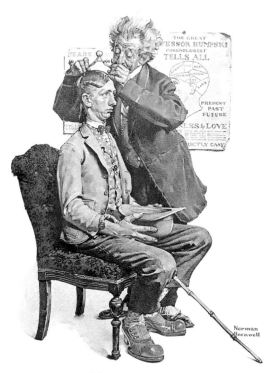

PHRENOLOGIST

Post Cover • March 27, 1926

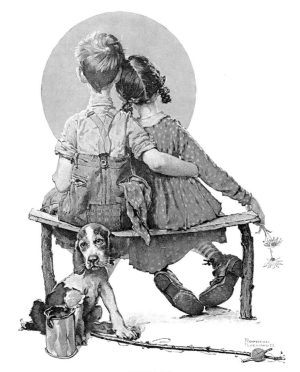

SUNSET

Post Cover • April 24, 1926

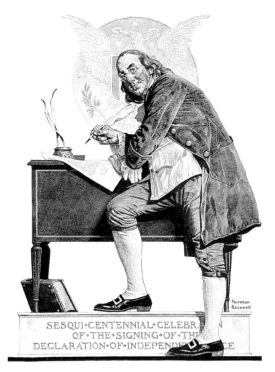

SESQUI·CENTENNIAL·CELEBRATION
OF·THE·SIGNING·OF·THE
DECLARATION·OF·INDEPENDENCE

DECLARATION OF INDEPENDENCE

Post Cover • May 29, 1926

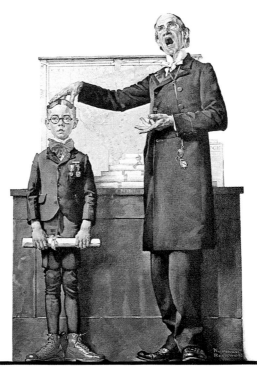

THE SCHOLAR

Post Cover • June 26, 1926

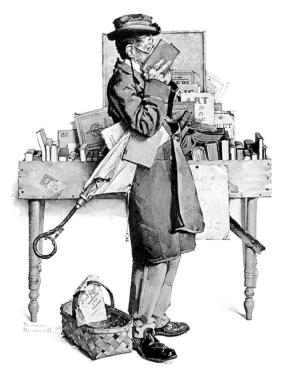

THE BOOKWORM

Post Cover • August 14, 1926

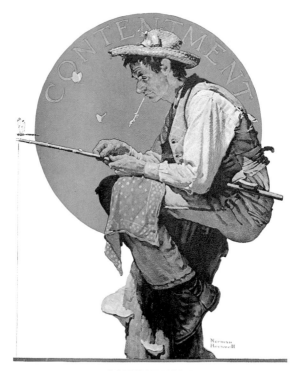

CONTENTMENT

Post Cover • August 28, 1926

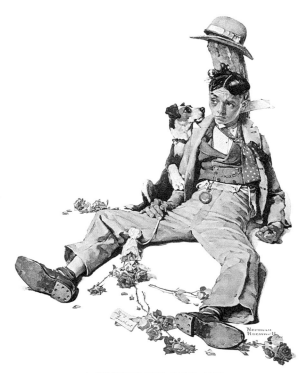

A TEMPORARY SETBACK

Post Cover • October 2, 1926

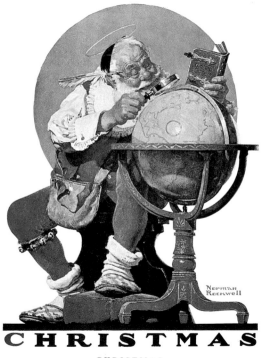

CHRISTMAS

CHRISTMAS

Post Cover • *December 4, 1926*

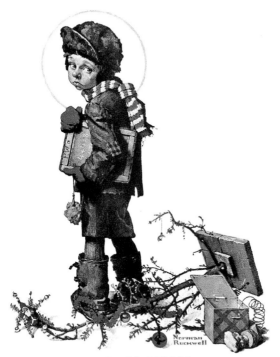

BACK TO SCHOOL

Post Cover • January 8, 1927

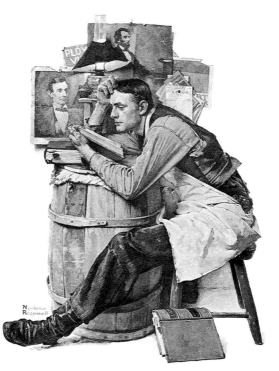

THE LAW STUDENT

Post Cover • February 19, 1927

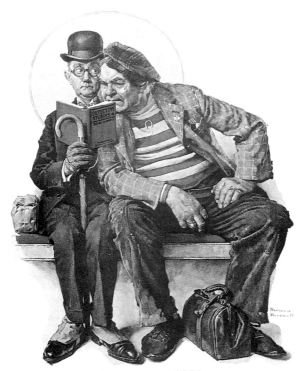

THE INTERLOPER

Post Cover • March 12, 1927

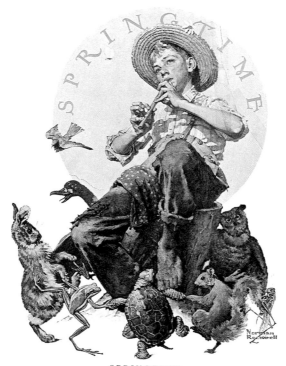

SPRINGTIME

Post Cover • April 16, 1927

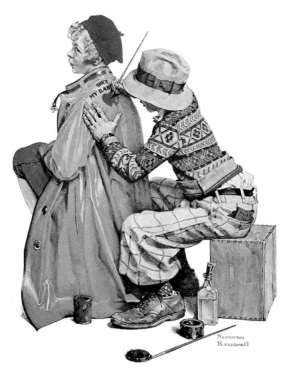

THE ARTIST
Post Cover • June 4, 1927

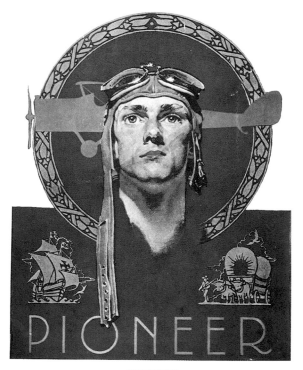

PIONEER

Post Cover • July 23, 1927

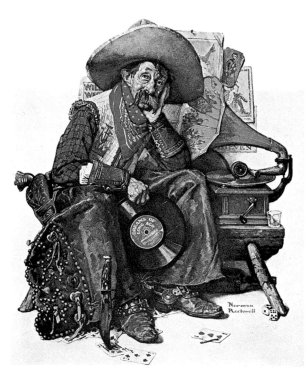

DREAMS OF LONG AGO

Post Cover • August 13, 1927

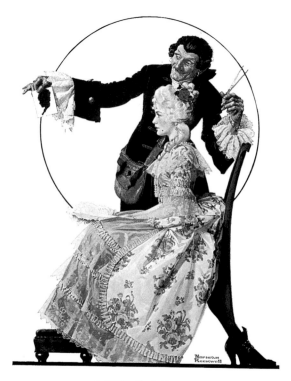

A NEW HAIRSTYLE

Post Cover • *September 24, 1927*

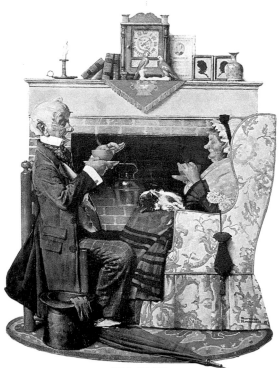

TEA TIME

Post Cover • October 22, 1927

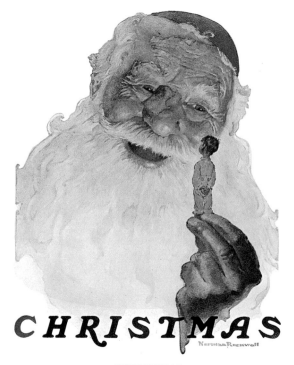

CHRISTMAS

CHRISTMAS
Post Cover • December 3, 1927

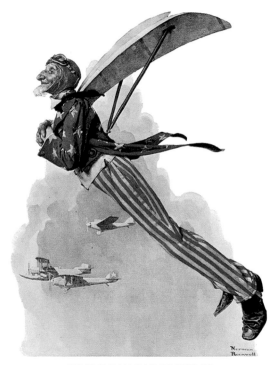

UNCLE SAM TAKES WINGS

Post Cover • January 21, 1928

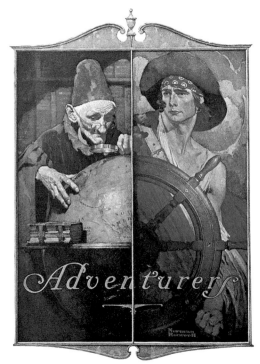

ADVENTURERS

Post Cover • April 14, 1928

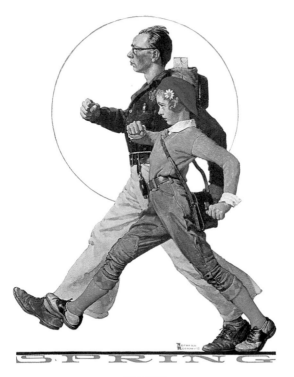

SPRING

Post Cover • May 5, 1928

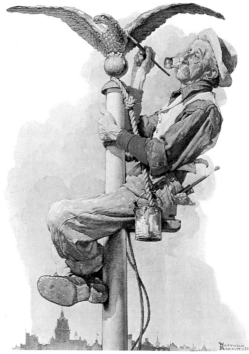

MAN PAINTING
FLAGPOLE
Post Cover • May 26, 1928

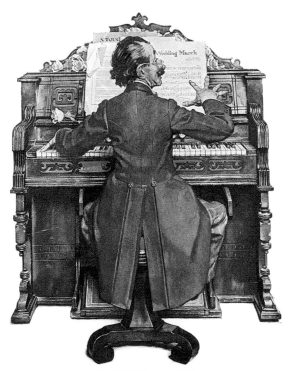

WEDDING MARCH

Post Cover • June 23, 1928

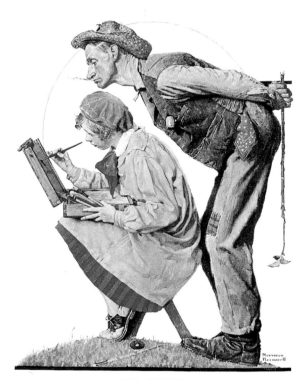

THE CRITIC

Post Cover • July 21, 1928

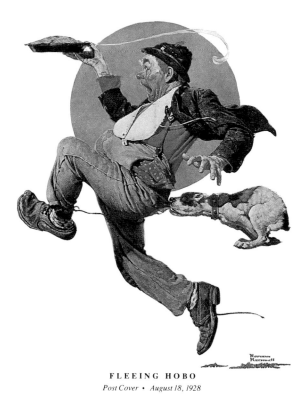

FLEEING HOBO

Post Cover • August 18, 1928

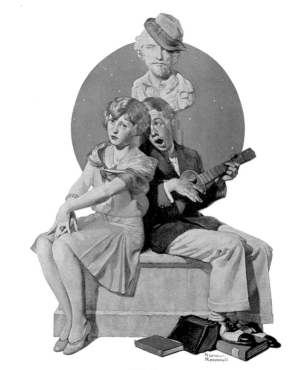

SERENADE

Post Cover • September 22, 1928

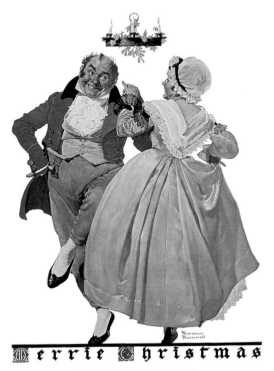

MERRIE CHRISTMAS
Post Cover • December 8, 1928

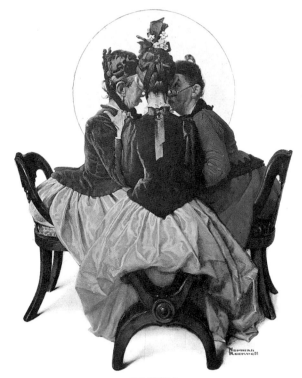

GOSSIPS

Post Cover • January 12, 1929

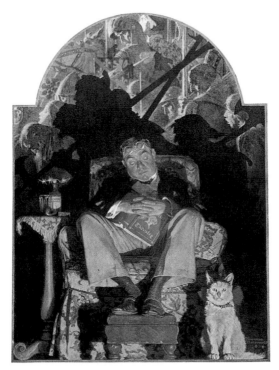

THE AGE OF CHIVALRY

Post Cover • February 16, 1929

SATURDAY EVENING POST COVERS

March 9, 1929–June 17, 1933

Rockwell Was One of the Lucky Few Who Was Not Much Affected
by the Depression

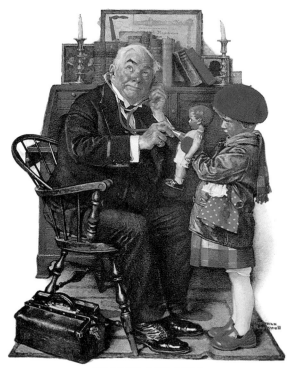

DOCTOR AND DOLL

Post Cover • March 9, 1929

SPEED TRAP

Post Cover • *April 20, 1929*

TWINS

Post Cover • May 4, 1929

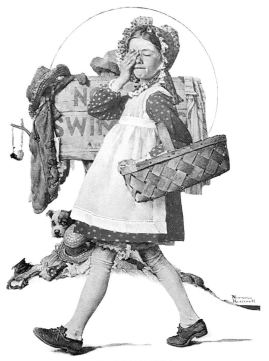

NO SWIMMING

Post Cover • June 15, 1929

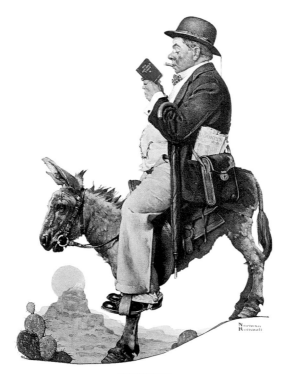

TOURIST

Post Cover • July 13, 1929

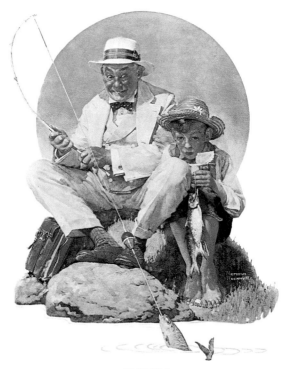

FISHING

Post Cover • August 3, 1929

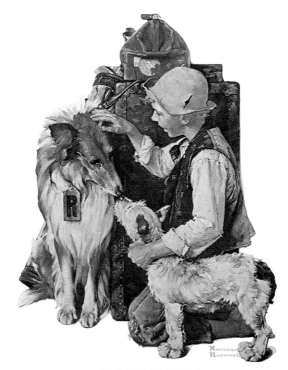

MAKING FRIENDS

Post Cover • September 28, 1929

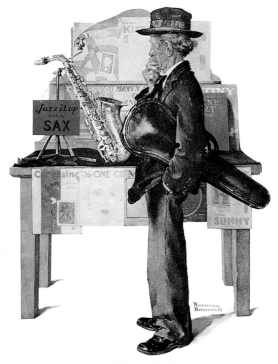

JAZZ IT UP

Post Cover • November 2, 1929

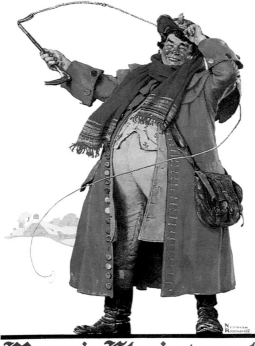

𝕸𝖊𝖗𝖗𝖎𝖊𝕮𝖍𝖗𝖎𝖘𝖙𝖒𝖆𝖘

MERRIE CHRISTMAS

Post Cover • December 7, 1929

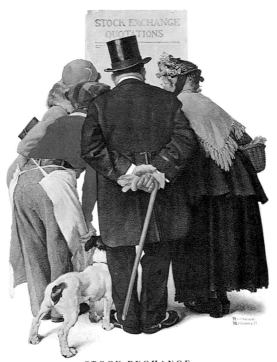

**STOCK EXCHANGE
QUOTATIONS**

Post Cover • *January 18, 1930*

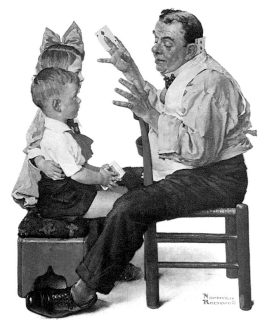

NOTHING UP HIS SLEEVE

Post Cover • *March 22, 1930*

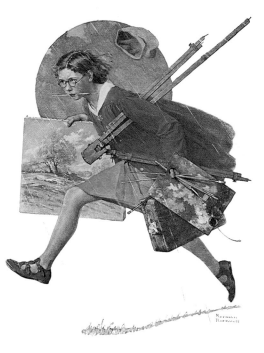

APRIL SHOWERS

Post Cover • April 12, 1930

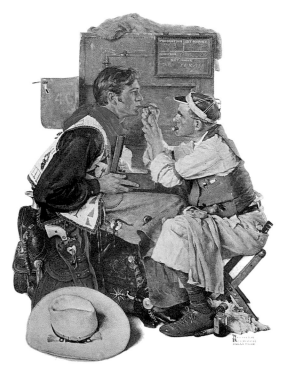

GARY COOPER

Post Cover • May 24, 1930

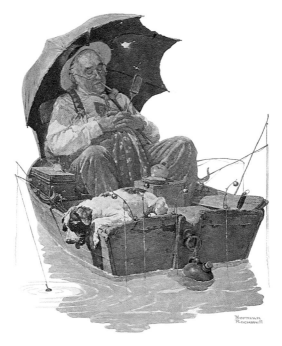

GONE FISHING

Post Cover • *July 19, 1930*

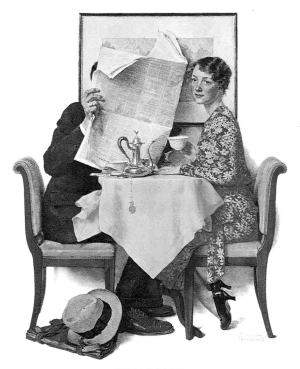

BREAKFAST

Post Cover • August 23, 1930

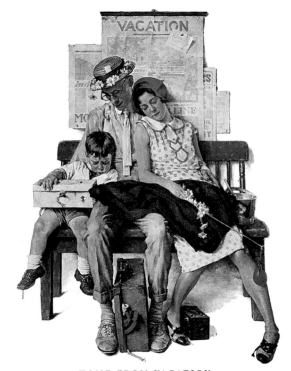

HOME FROM VACATION

Post Cover • September 13, 1930

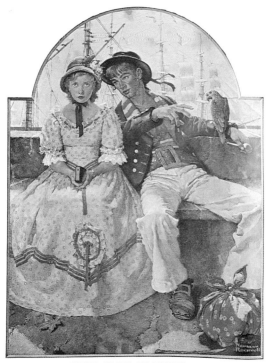

THE YARN SPINNER

Post Cover • November 8, 1930

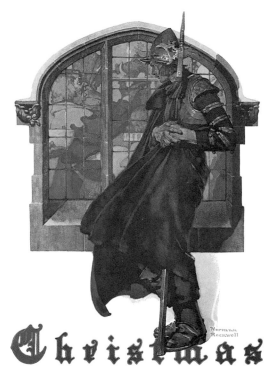

CHRISTMAS

Post Cover • December 6, 1930

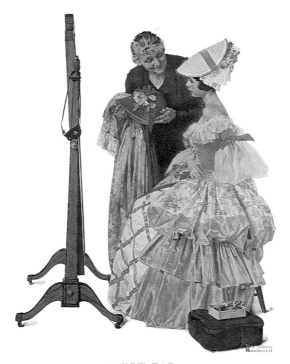

A NEW HAT

Post Cover • January 31, 1931

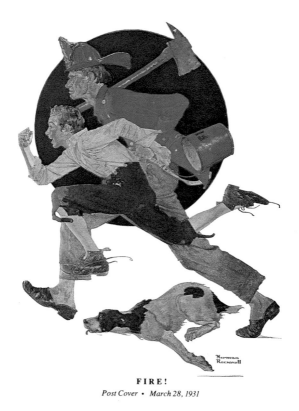

FIRE!

Post Cover • March 28, 1931

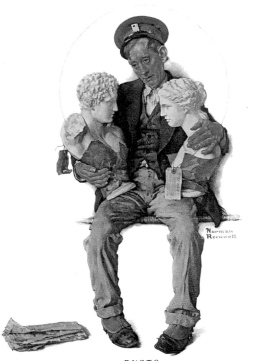

BUSTS

Post Cover • April 18, 1931

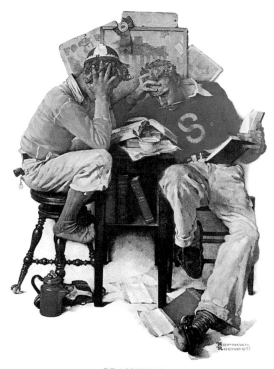

CRAMMING

Post Cover • June 13, 1931

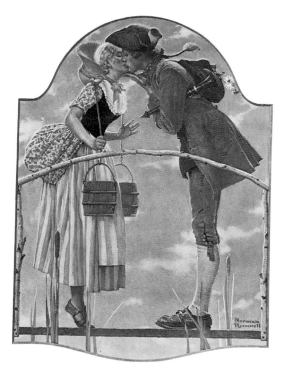

THE MILKMAID

Post Cover • July 25, 1931

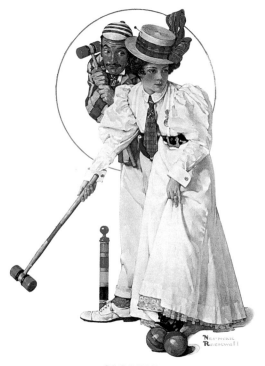

CROQUET

Post Cover • September 5, 1931

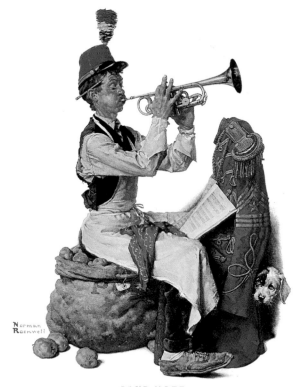

SOUR NOTE

Post Cover • November 7, 1931

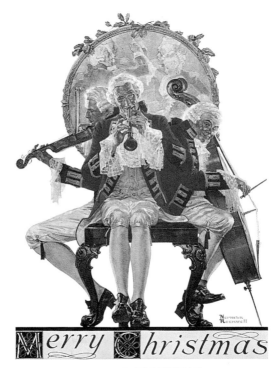

MERRY CHRISTMAS

Post Cover • December 12, 1931

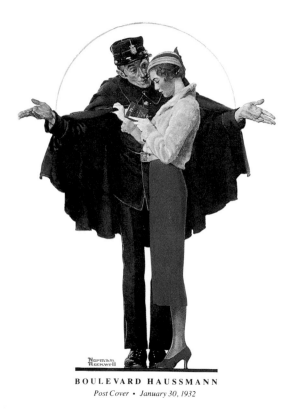

BOULEVARD HAUSSMANN

Post Cover • January 30, 1932

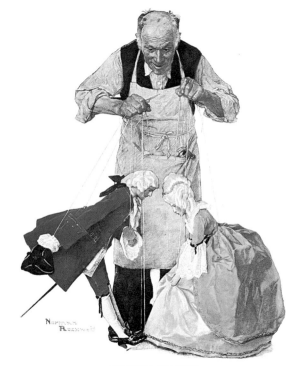

PUPPET MAKER

Post Cover • October 22, 1932

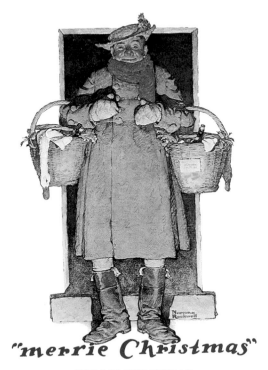

"merrie Christmas"

MERRIE CHRISTMAS

Post Cover • December 10, 1932

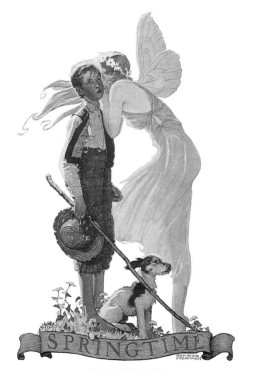

SPRINGTIME

Post Cover • April 8, 1933

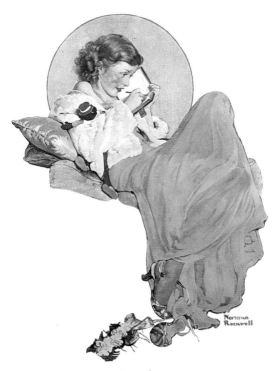

THE DIARY

Post Cover • June 17, 1933

SATURDAY EVENING POST COVERS

August 5, 1933–February 19, 1938

Rockwell's Work Was Becoming More Personal

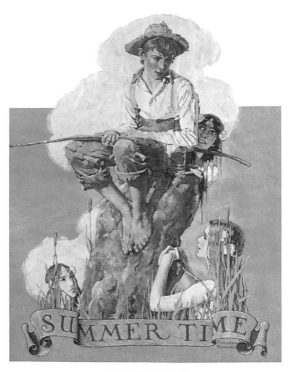

SUMMERTIME

Post Cover • August 5, 1933

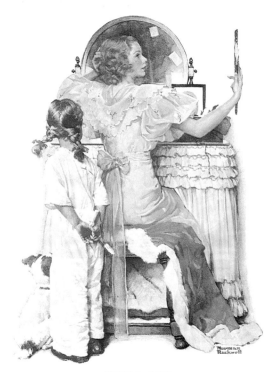

GOING OUT

Post Cover • *October 21, 1933*

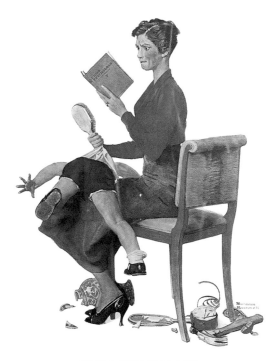

CHILD PSYCHOLOGY

Post Cover • November 25, 1933

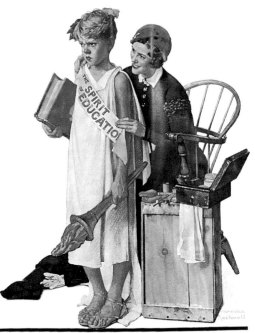

THE SPIRIT OF
EDUCATION

Post Cover • *April 21, 1934*

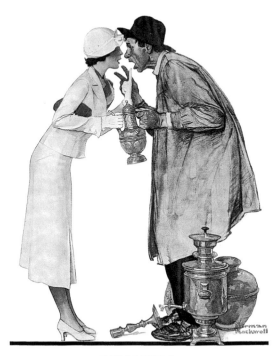

BARGAINING

Post Cover • May 19, 1934

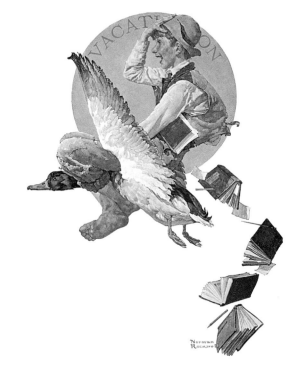

VACATION

Post Cover • June 30, 1934

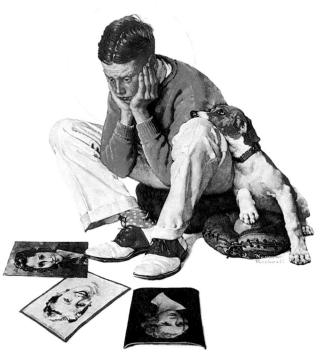

STARSTRUCK

Post Cover • September 22, 1934

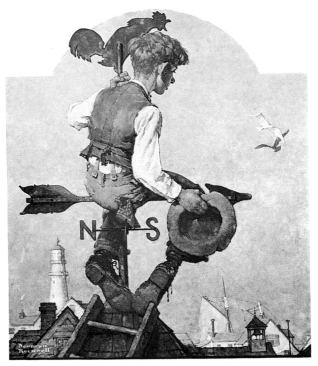

UNDER SAIL
Post Cover • October 20, 1934

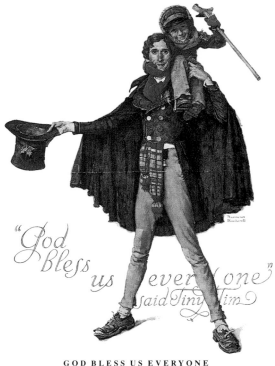

"God bless us ever one" said Tiny Tim

GOD BLESS US EVERYONE

Post Cover • December 15, 1934

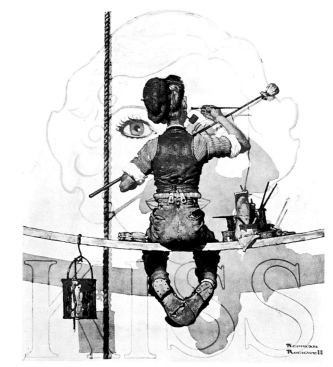

BILLBOARD PAINTER

Post Cover • February 9, 1935

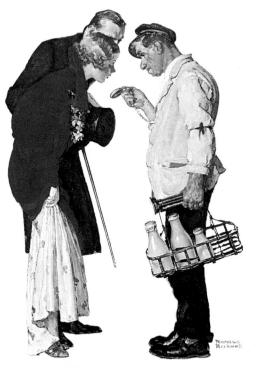

THE PARTYGOERS

Post Cover • March 9, 1935

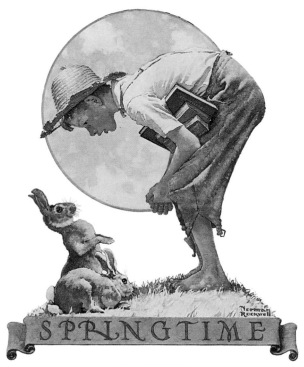

SPRINGTIME

Post Cover • April 27, 1935

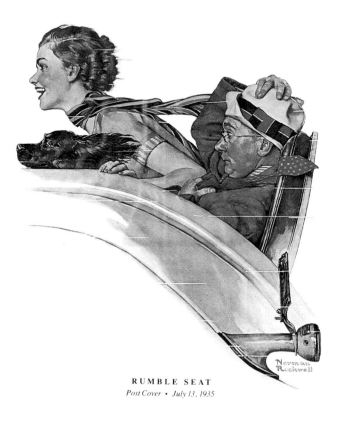

RUMBLE SEAT

Post Cover • July 13, 1935

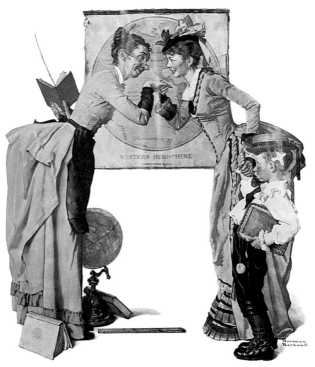

WESTERN HEMISPHERE

SCHOOL DAYS

Post Cover • September 14, 1935

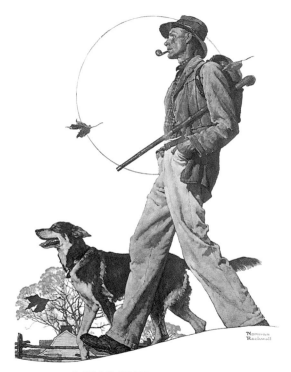

A WALK IN THE COUNTRY

Post Cover • *November 16, 1935*

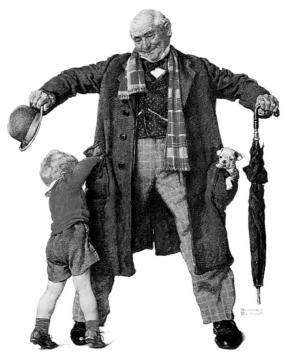

THE GIFT

Post Cover • January 25, 1936

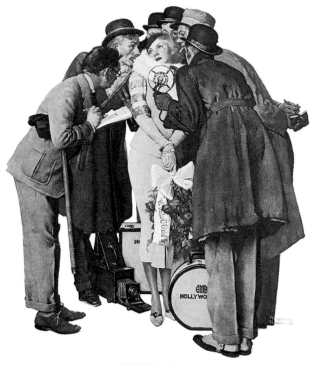

MOVIE STAR

Post Cover • March 7, 1936

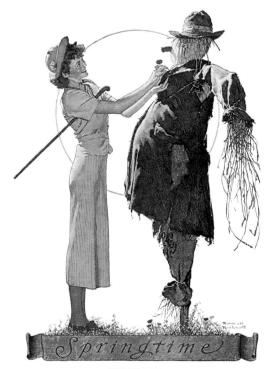

SPRINGTIME

Post Cover • April 25, 1936

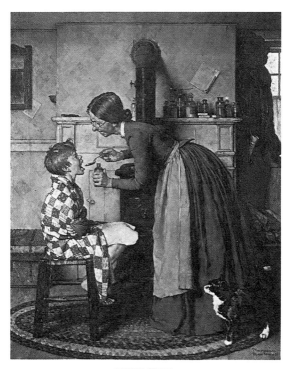

MEDICINE

Post Cover • May 30, 1936

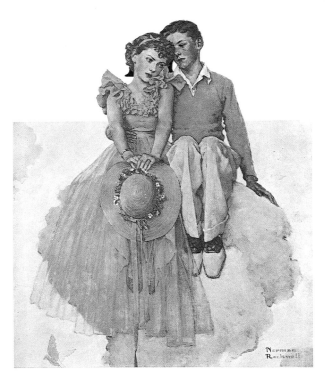

YOUNG LOVE

Post Cover • July 11, 1936

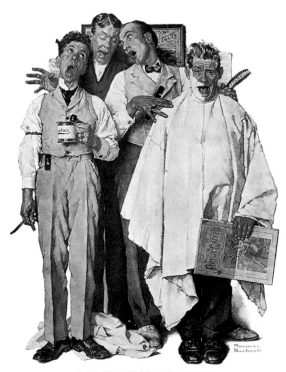

BARBERSHOP QUARTET

Post Cover • September 26, 1936

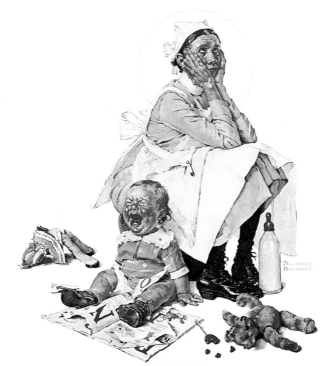

THE NANNY

Post Cover • October 24, 1936

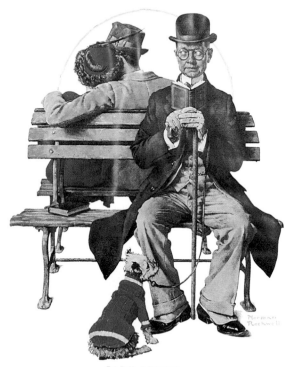

PARK BENCH

Post Cover • November 21, 1936

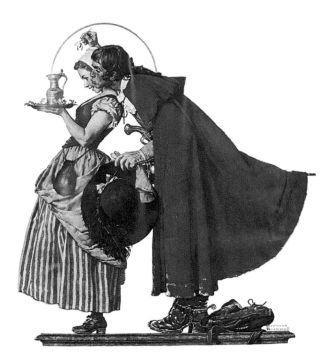

MISTLETOE

Post Cover • December 19, 1936

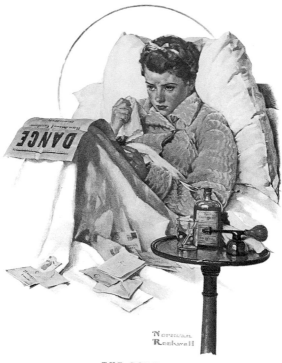

THE COLD

Post Cover • January 23, 1937

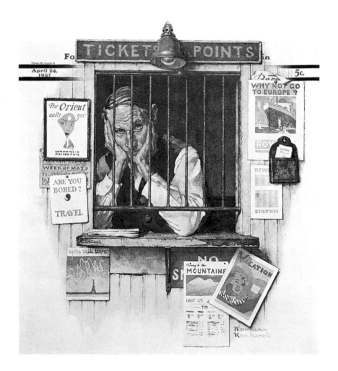

TICKET AGENT

Post Cover • April 24, 1937.

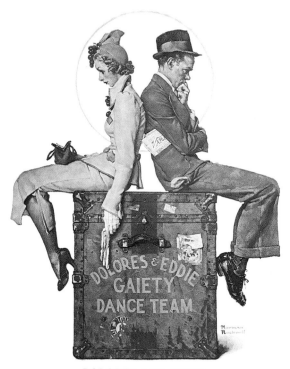

DOLORES AND EDDIE

Post Cover • June 12, 1937

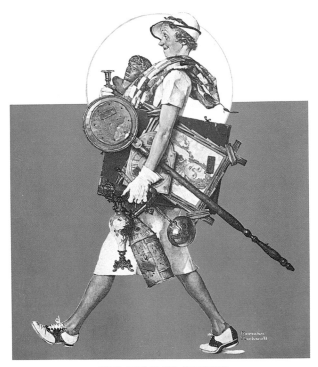

THE ANTIQUE HUNTER

Post Cover • July 31, 1937

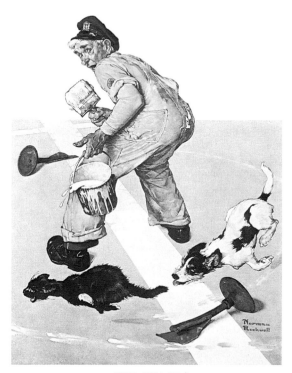

THE CHASE

Post Cover • October 2, 1937

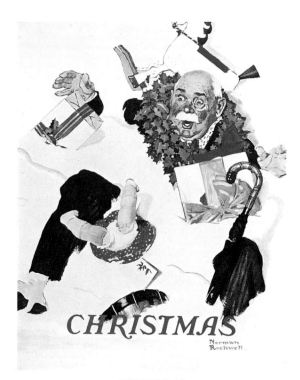

CHRISTMAS

Post Cover • December 25, 1937

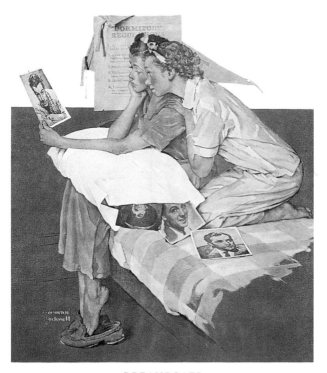

DREAMBOATS

Post Cover • February 19, 1938

SATURDAY EVENING POST COVERS
April 23, 1938–July 25, 1942

Rockwell Was Now on the Verge of a Major Breakthrough

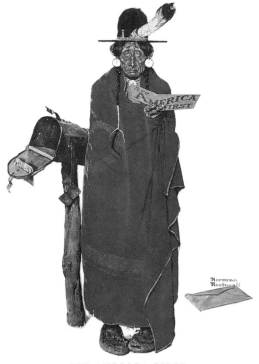

SEE AMERICA FIRST

Post Cover • April 23, 1938

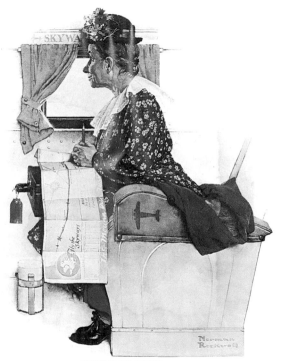

FIRST FLIGHT

Post Cover • June 4, 1938

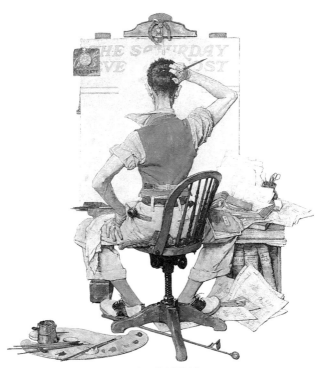

BLANK CANVAS

Post Cover • October 8, 1938

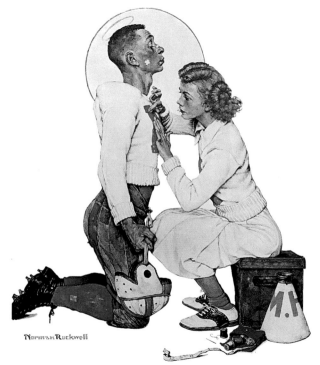

LETTERMAN

Post Cover • November 19, 1938

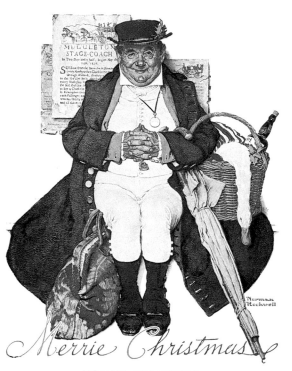

MERRIE CHRISTMAS

Post Cover • December 17, 1938

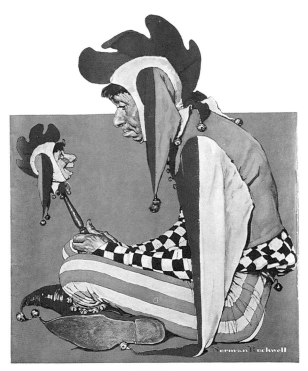

JESTER

Post Cover • February 11, 1939

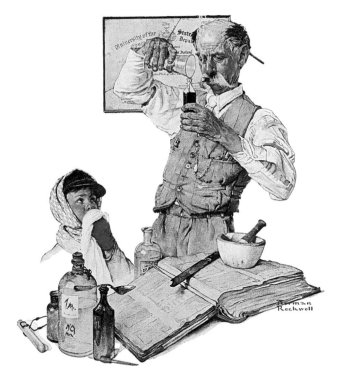

THE DRUGGIST

Post Cover • March 18, 1939

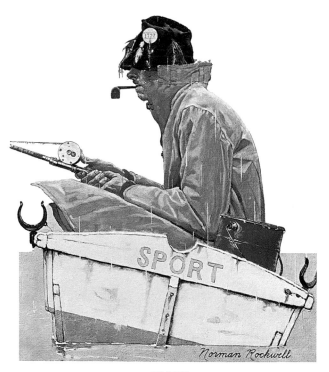

SPORT

Post Cover • April 29, 1939

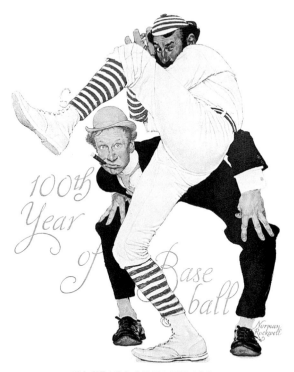

100th
Year
of
Base
ball

100 YEARS OF BASEBALL

Post Cover • *July 8, 1939*

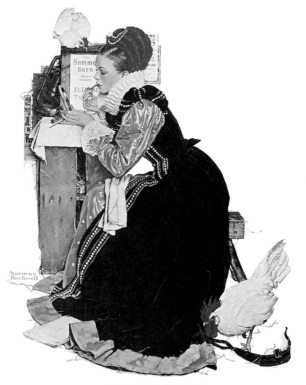

SUMMER STOCK

Post Cover • August 5, 1939

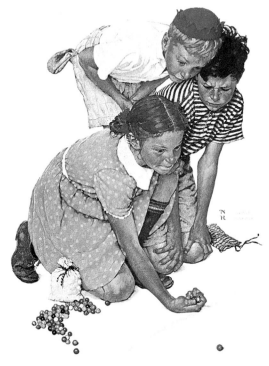

MARBLES CHAMPION

Post Cover • September 2, 1939

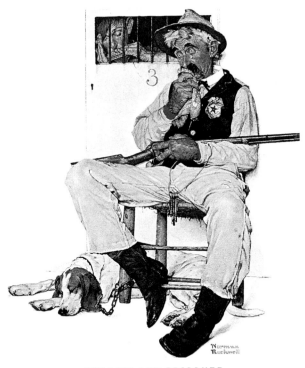

SHERIFF AND PRISONER

Post Cover • *November 4, 1939*

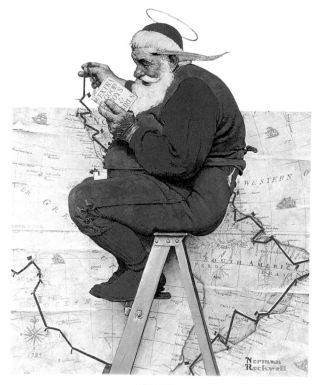

SANTA

Post Cover • December 16, 1939

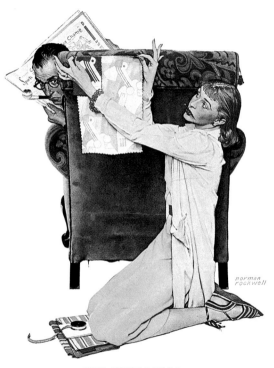

THE DECORATOR

Post Cover • March 30, 1940

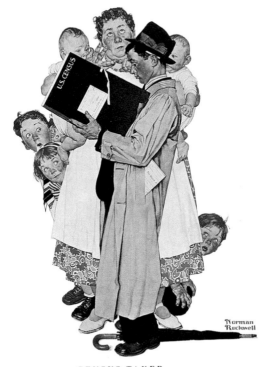

CENSUS TAKER

Post Cover • April 27, 1940

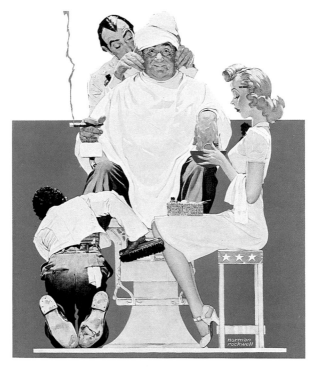

THE FULL TREATMENT

Post Cover • May 18, 1940

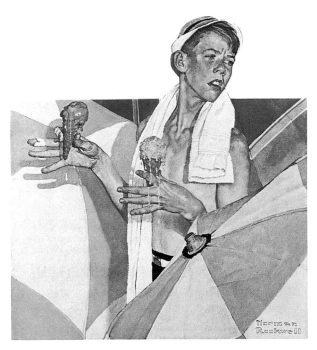

BEACH SCENE

Post Cover • July 13, 1940

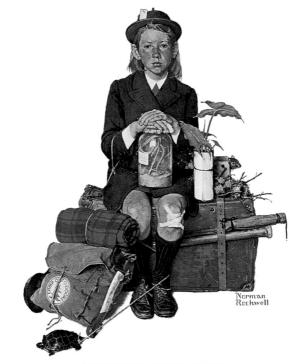

RETURNING FROM CAMP

Post Cover • August 24, 1940

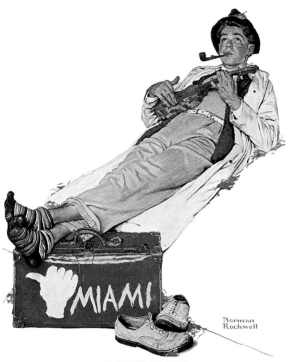

MIAMI BOUND

Post Cover • November 30, 1940

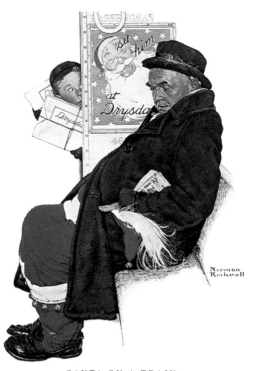

SANTA ON A TRAIN

Post Cover • December 28, 1940

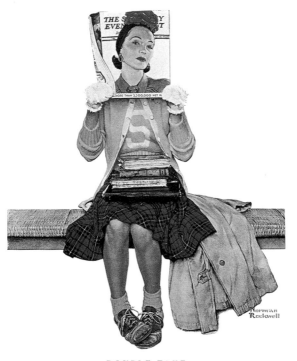

DOUBLE TAKE

Post Cover • March 1, 1941

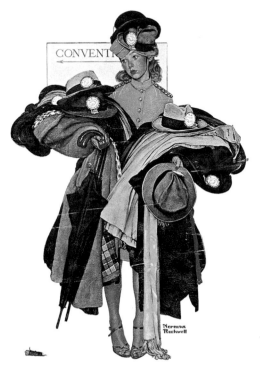

HATCHECK GIRL

Post Cover • May 3, 1941

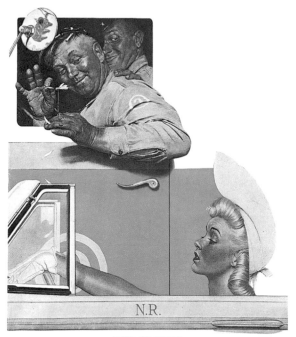

THE FLIRTS

Post Cover • July 26, 1941

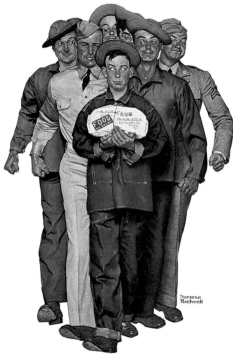

PACKAGE FROM HOME

Post Cover • October 4, 1941

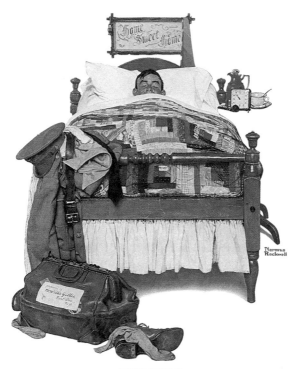

FURLOUGH

Post Cover • November 29, 1941

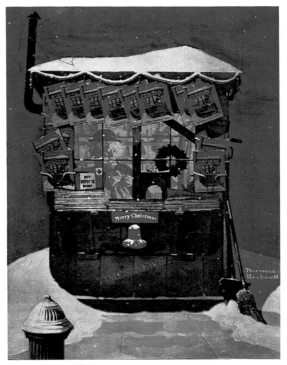

NEWSSTAND IN THE SNOW

Post Cover • December 20, 1941

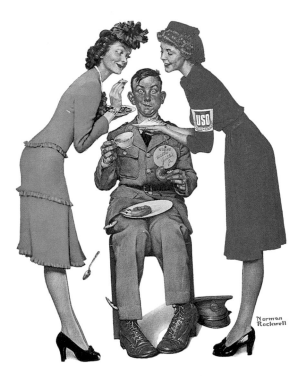

USO VOLUNTEERS

Post Cover • February 7, 1942

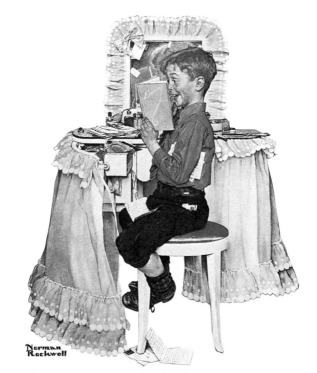

SECRETS

Post Cover • March 21, 1942

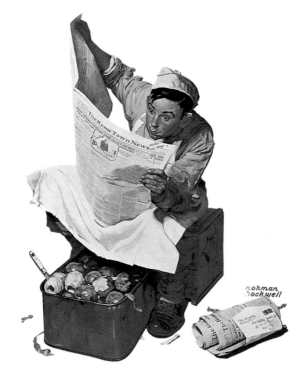

HOMETOWN NEWS

Post Cover • April 11, 1942

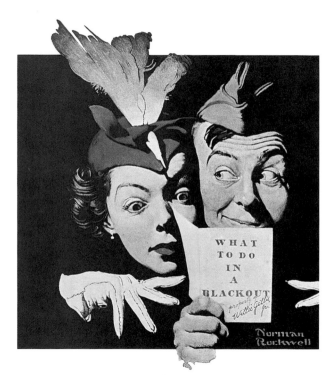

BLACKOUT

Post Cover • June 27, 1942

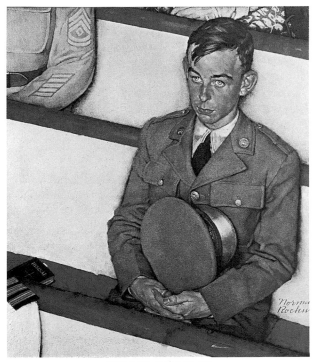

WILLIE GILLIS IN CHURCH

Post Cover • July 25, 1942

SATURDAY EVENING POST COVERS
September 5, 1942–November 16, 1946

Rockwell's Authority Was Based on the Trust of the American Public

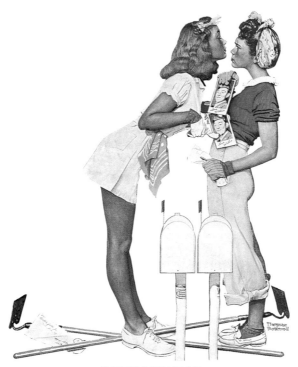

CONFRONTATION

Post Cover • September 5, 1942

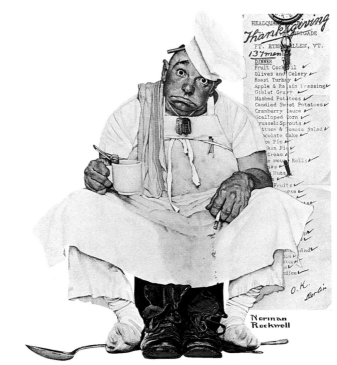

THANKSGIVING DAY

Post Cover • November 28, 1942

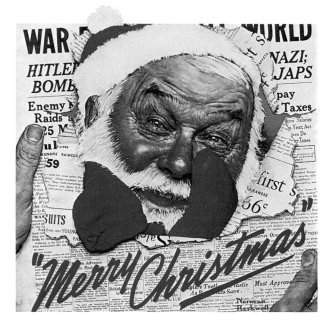

MERRY CHRISTMAS

Post Cover • December 26, 1942

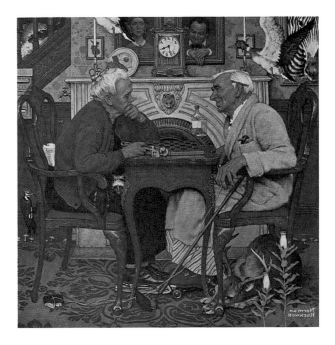

THE GAME

Post Cover • April 3, 1943

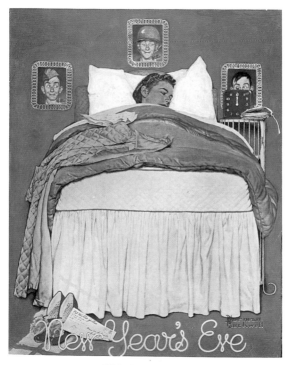

AULD LANG SYNE

Post Cover • January 1, 1944

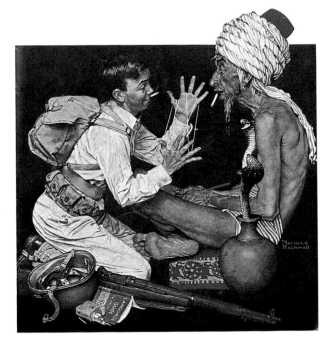

CAT'S CRADLE

Post Cover • June 26, 1943

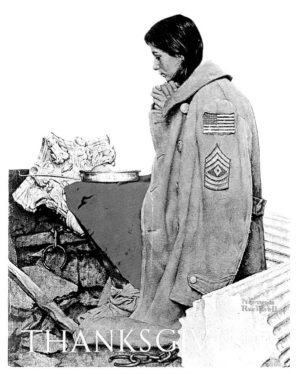

THANKSGIVING

Post Cover • November 27, 1943

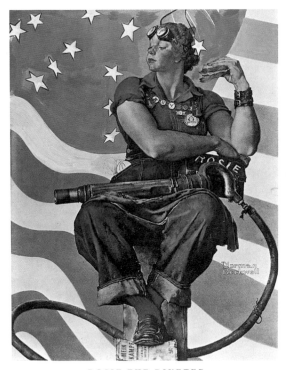

ROSIE THE RIVETER

Post Cover • May 29, 1943

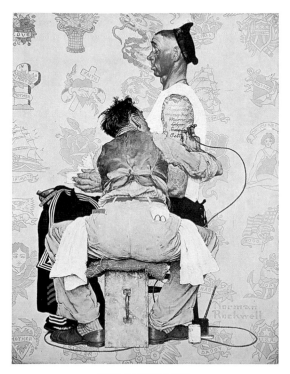

THE TATTOOIST

Post Cover • March 4, 1944

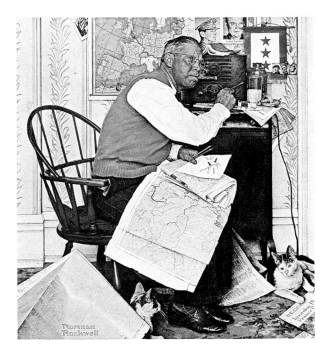

ARMCHAIR GENERAL

Post Cover • April 29, 1944

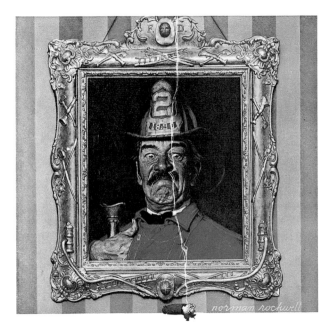

FIRE!

Post Cover • May 27, 1944

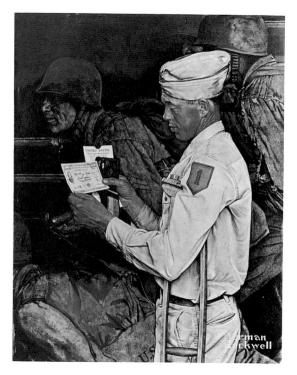

WAR BOND

Post Cover • July 1, 1944

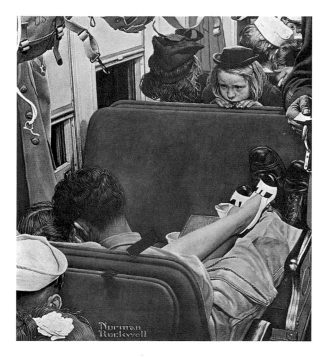

VOYEUR

Post Cover • August 12, 1944

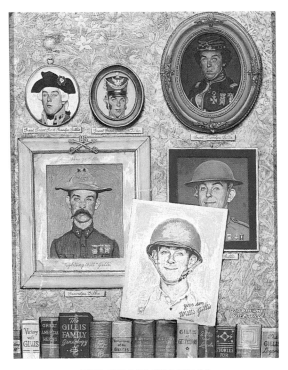

THE GILLIS HERITAGE

Post Cover • September 16, 1944

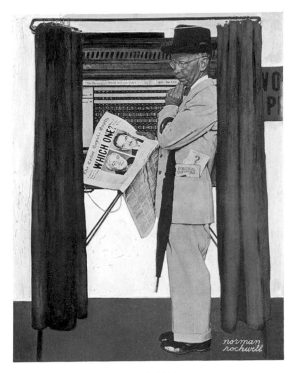

WHICH ONE?

Post Cover • November 4, 1944

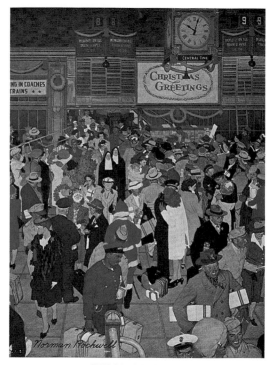

UNION STATION,
CHICAGO

Post Cover • December 23, 1944

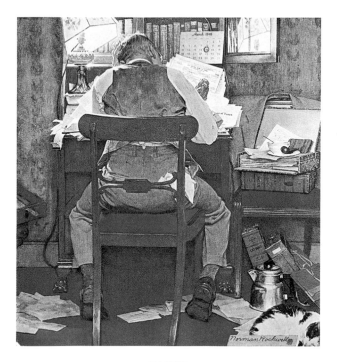

TAXES

Post Cover • March 17, 1945

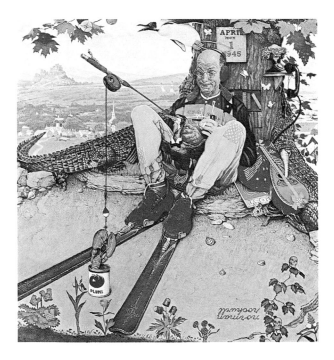

APRIL FOOL

Post Cover • *March 31, 1945*

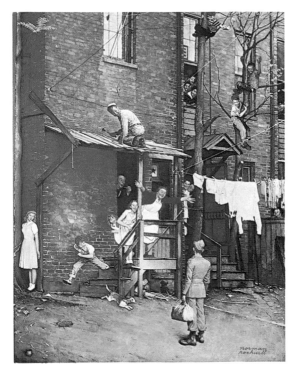

HOMECOMING GI

Post Cover • May 26, 1945

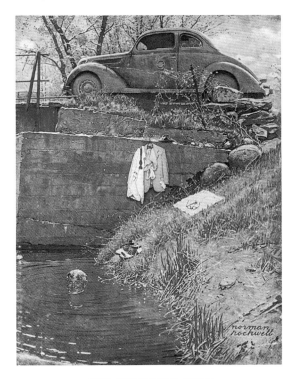

THE SWIMMING HOLE

Post Cover • August 11, 1945

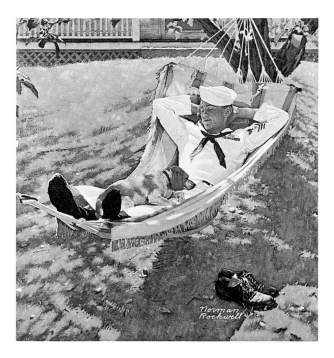

ON LEAVE

Post Cover • September 15, 1945

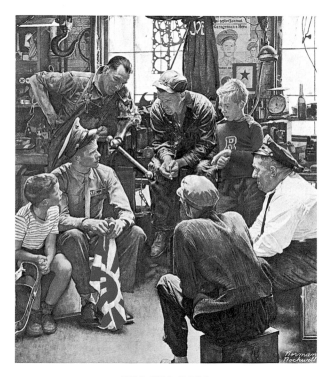

THE WAR HERO

Post Cover • October 13, 1945

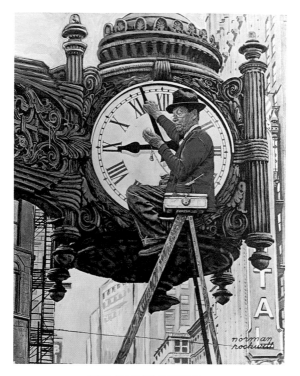

THE CLOCK MENDER

Post Cover • November 3, 1945

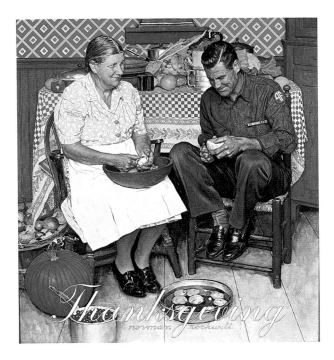

THANKSGIVING

Post Cover • November 24, 1945

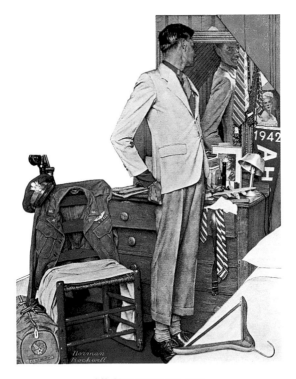

AN IMPERFECT FIT

Post Cover • December 15, 1945

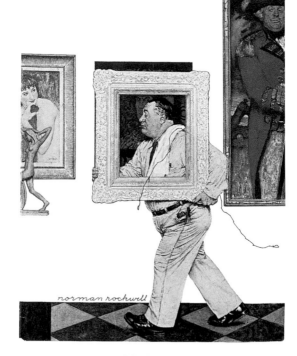

PORTRAIT

Post Cover • March 2, 1946

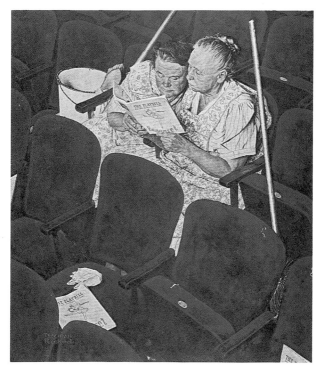

PLAYBILL

Post Cover • April 6, 1946

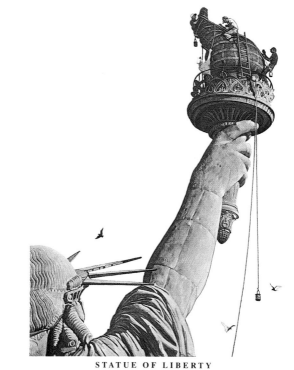

STATUE OF LIBERTY

Post Cover • July 6, 1946

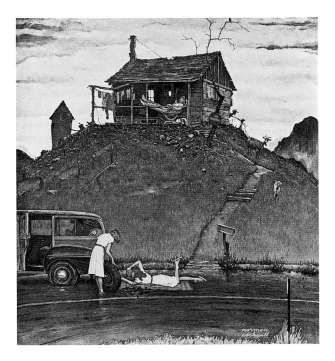

FIXING A FLAT

Post Cover • August 3, 1946

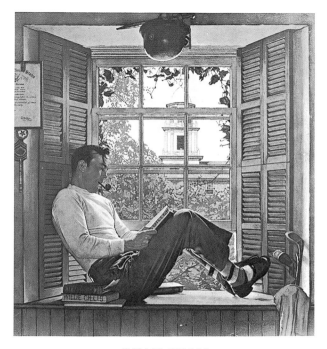

WILLIE GILLIS
AT COLLEGE

Post Cover • October 5, 1946

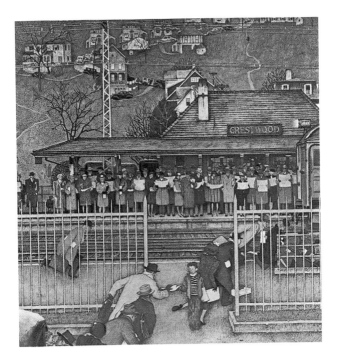

COMMUTERS

Post Cover • November 16, 1946

SATURDAY EVENING POST COVERS

December 7, 1946–January 3, 1953

During the Postwar Years Rockwell Could Hardly Pick Up a Brush
Without Producing a Memorable Image

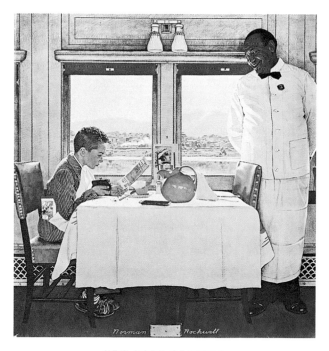

NEW YORK CENTRAL
DINER

Post Cover • December 7, 1946

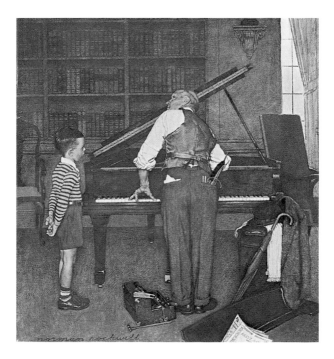

PIANO TUNER

Post Cover • January 11, 1947

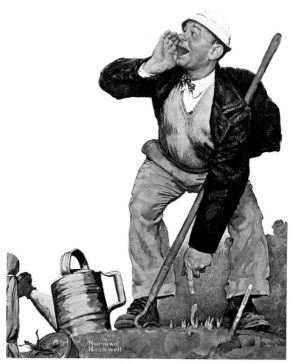

CROCUSES

Post Cover • March 22, 1947

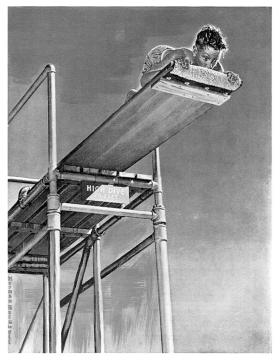

HIGH BOARD

Post Cover • August 16, 1947

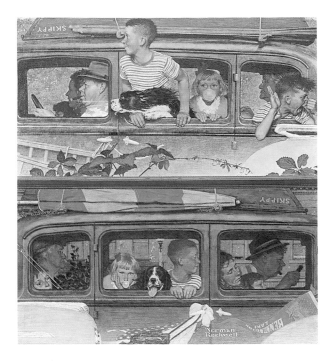

THE OUTING

Post Cover • August 30, 1947

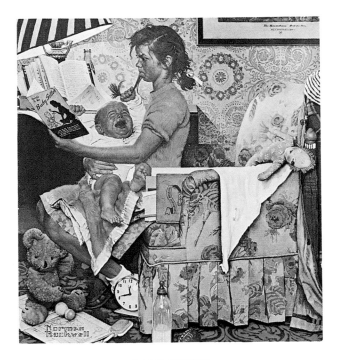

BABY SITTER

Post Cover • November 8, 1947

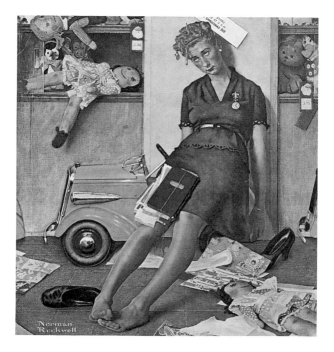

CHRISTMAS RUSH

Post Cover • December 27, 1947

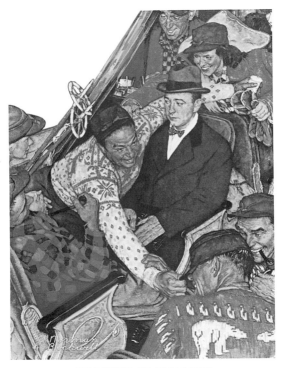

WEEKEND TRAVELLERS

Post Cover • January 24, 1948

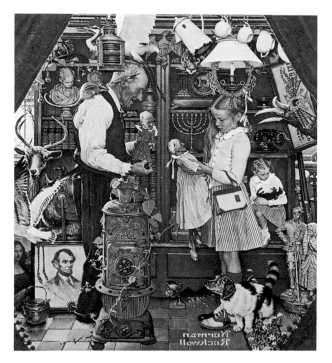

CURIOSITY SHOP

Post Cover • April 3, 1948

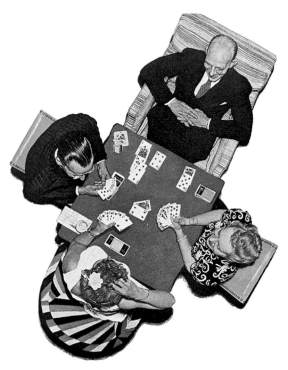

THE BID

Post Cover • *May 15, 1948*

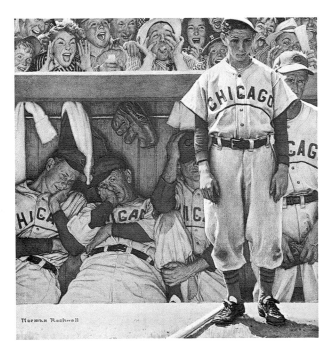

THE DUGOUT

Post Cover • September 4, 1948

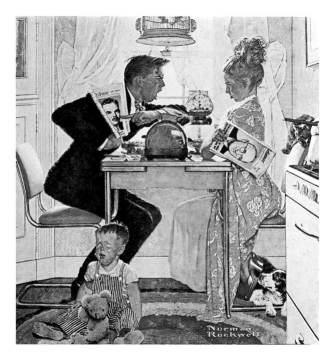

ELECTION DAY

Post Cover • October 30, 1948

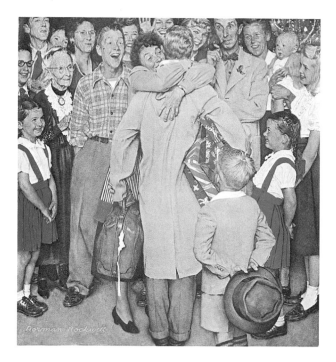

HOMECOMING

Post Cover • December 25, 1948

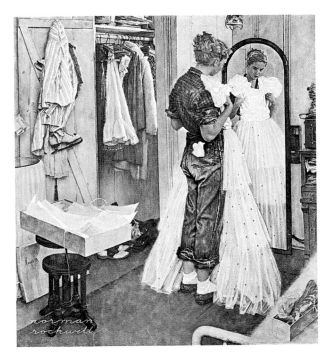

THE PROM DRESS

Post Cover • *March 19, 1949*

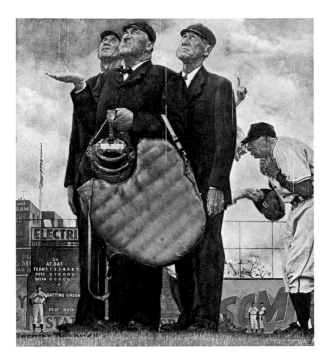

BOTTOM OF THE SIXTH

Post Cover • *April 23, 1949*

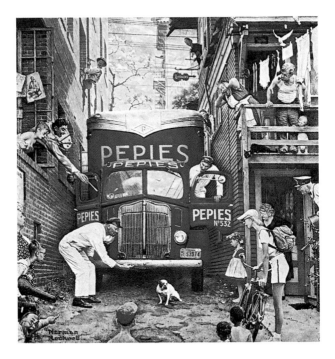

TRAFFIC CONDITIONS

Post Cover • July 9, 1949

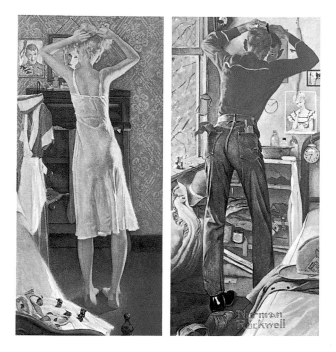

BEFORE THE DATE

Post Cover • September 24, 1949

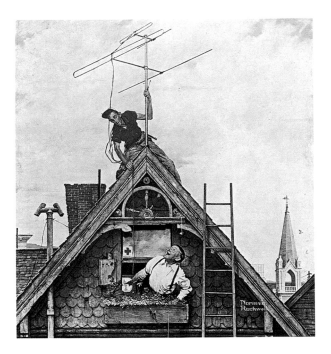

THE NEW TELEVISION SET

Post Cover • November 5, 1949

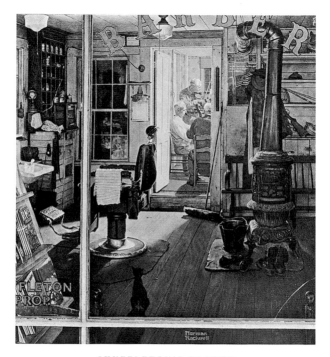

**SHUFFLETON'S BARBER
SHOP**

Post Cover • April 29, 1950

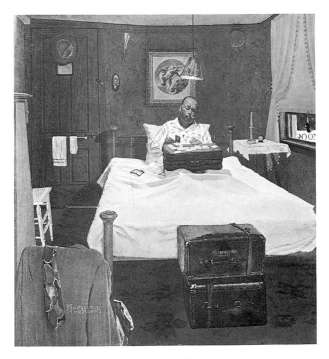

SOLITAIRE

Post Cover • August 19, 1950

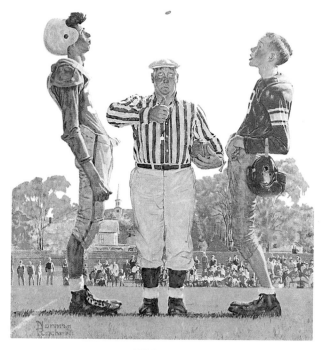

THE TOSS

Post Cover • October 21, 1950

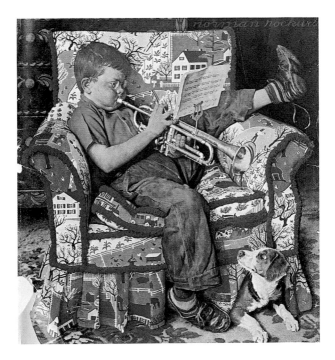

PRACTICE

Post Cover • November 18, 1950

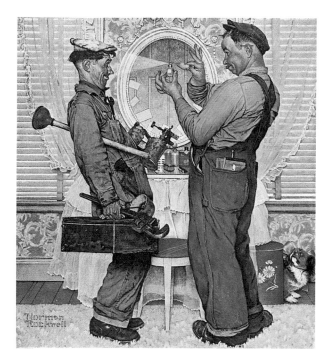

THE PLUMBERS

Post Cover • June 2, 1951

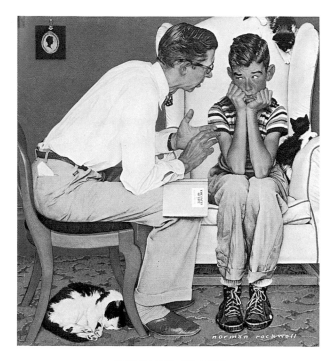

THE FACTS OF LIFE

Post Cover • July 14, 1951

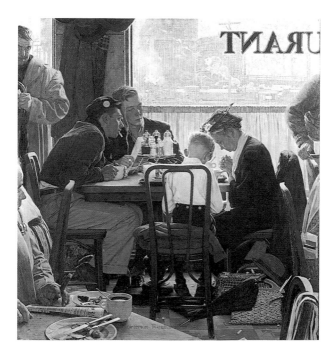

SAYING GRACE
Post Cover • November 24, 1951

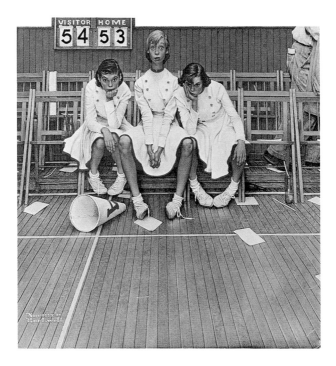

CHEERLEADERS

Post Cover • February 16, 1952

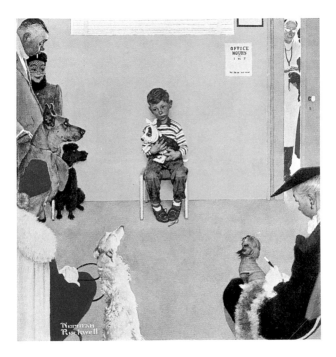

WAITING FOR THE VET

Post Cover • March 29, 1952

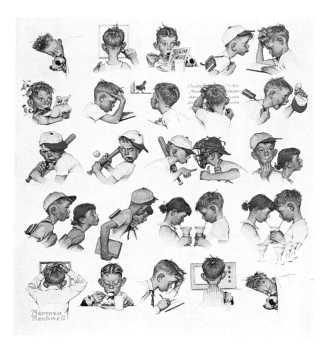

A DAY IN THE LIFE
OF A BOY

Post Cover • *May 24, 1952*

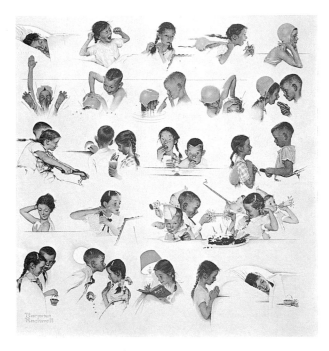

A DAY IN THE LIFE
OF A GIRL

Post Cover • August 30, 1952

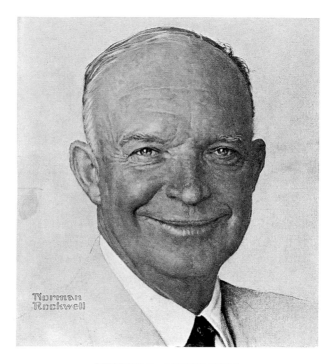

DWIGHT D. EISENHOWER

Post Cover • *October 11, 1952*

HOW TO DIET

Post Cover • *January 3, 1953*

SATURDAY EVENING POST COVERS
April 4, 1953–May 25, 1963

Rockwell's Style Puts Its Distinctive Mark on Everything

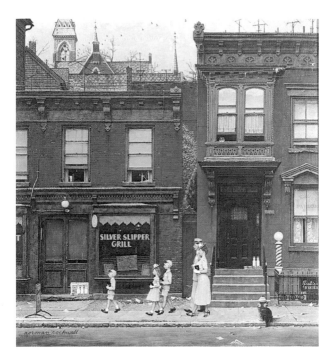

WALKING TO CHURCH

Post cover • *April 4, 1953*

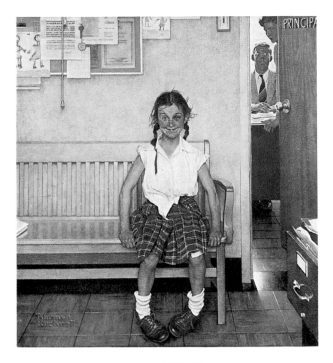

THE SHINER

Post Cover • May 23, 1953

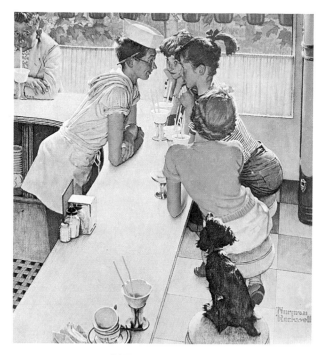

SODA FOUNTAIN
Post Cover • August 22, 1953

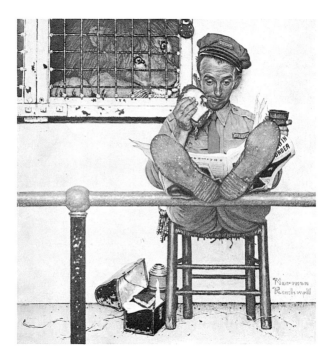

FEEDING TIME

Post Cover • January 9, 1954

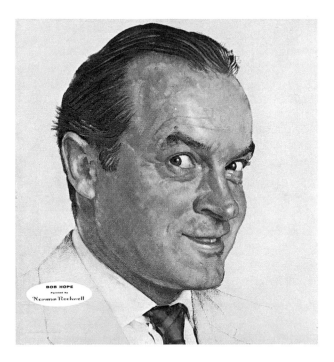

BOB HOPE

Post Covers • February 13, 1954

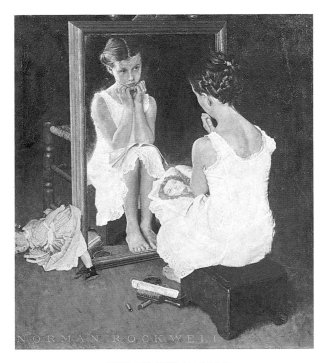

GIRL AT THE MIRROR

Post Cover • March 6, 1954

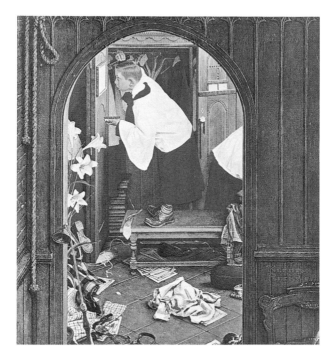

CHOIRBOY

Post Cover • April 17, 1954

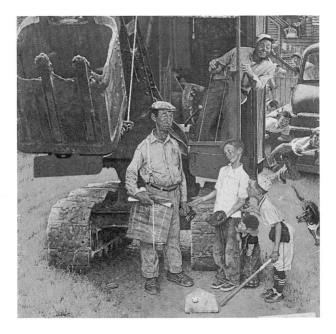

HOME PLATE

Post Cover • August 21, 1954

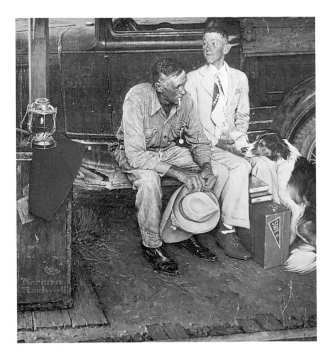

BREAKING HOME TIES

Post Cover • September 25, 1954

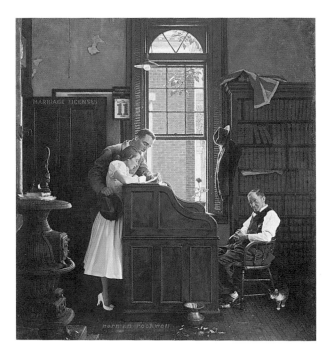

THE MARRIAGE LICENSE

Post Cover • *June 11, 1955*

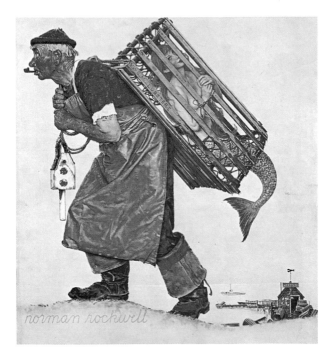

A FAIR CATCH

Post Cover • *August 20, 1955*

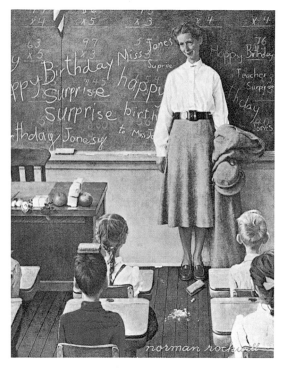

SURPRISE

Post Cover • March 17, 1956

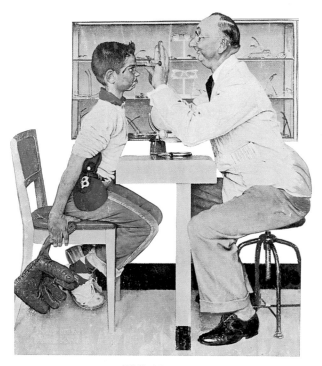

NEW GLASSES
Post Cover • *May 19, 1956*

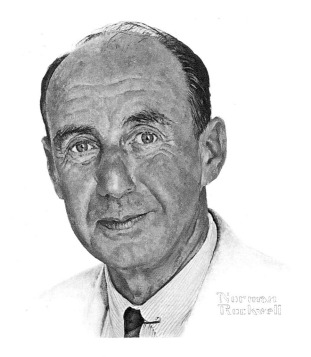

ADLAI STEVENSON

Post Cover • October 6, 1956

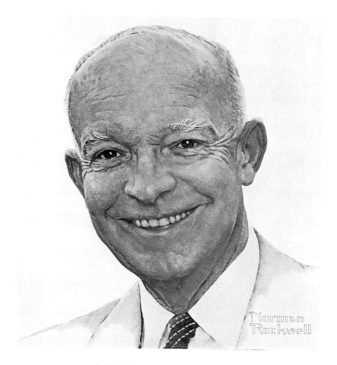

DWIGHT D. EISENHOWER

Post Cover • October 13, 1956

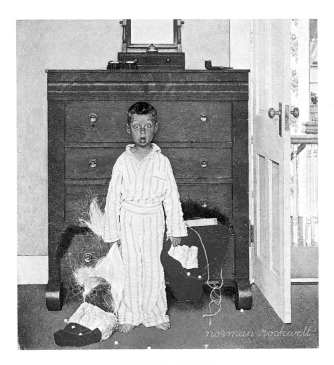

BOTTOM DRAWER

Post Cover • December 29, 1956

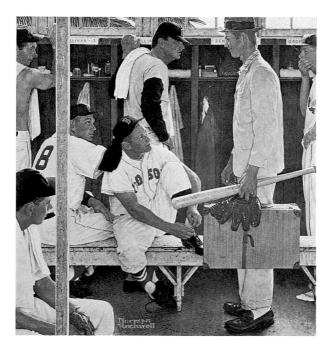

THE ROOKIE

Post Cover • *March 2, 1957*

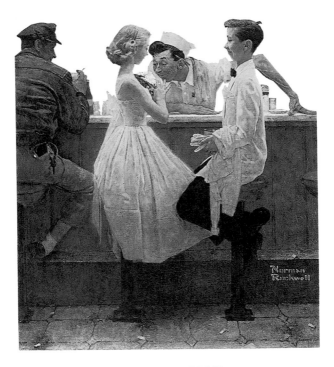

AFTER THE PROM

Post Cover • *May 25, 1957*

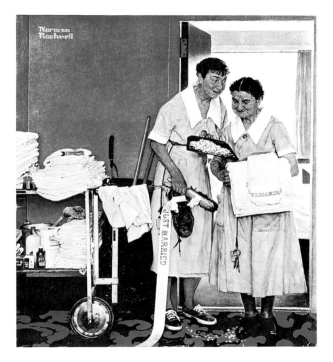

BRIDAL SUITE

Post Cover • June 29, 1957

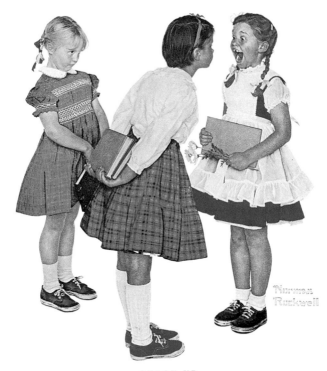

CHECK UP

Post Cover • September 7, 1957

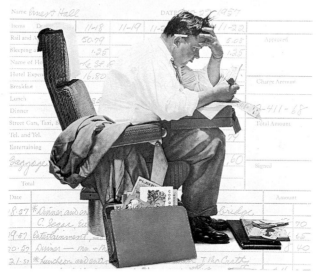

EXPENSES

Post Cover • *November 30, 1957*

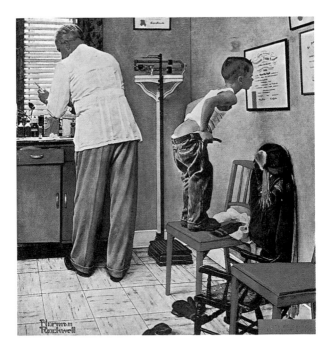

DOCTOR'S OFFICE

Post Cover • March 15, 1958

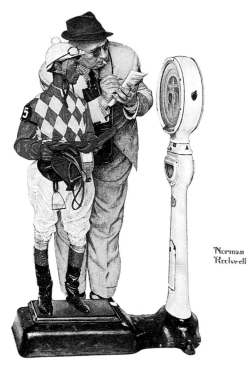

JOCKEY WEIGHING IN

Post Cover • June 28, 1958

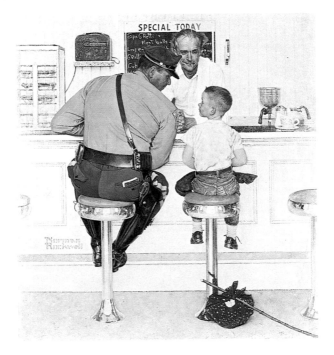

THE RUNAWAY

Post Cover • September 20, 1958

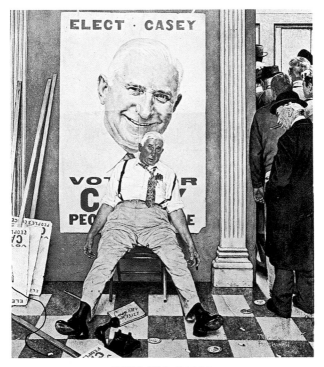

VOTE FOR CASEY

Post Cover • November 8, 1958

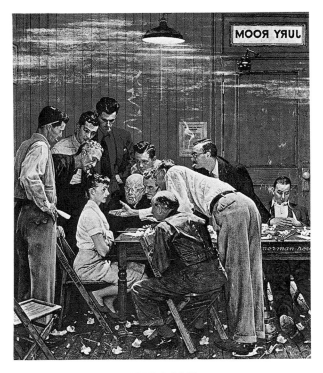

JURY ROOM

Post Cover • February 14, 1959

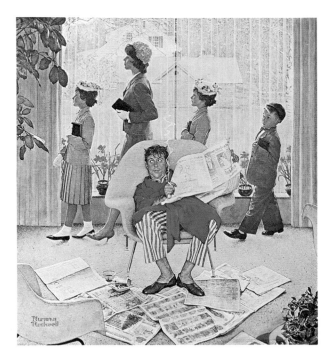

EASTER MORNING

Post Cover • *May 16, 1959*

THE GRADUATE

Post Cover • June 6, 1959

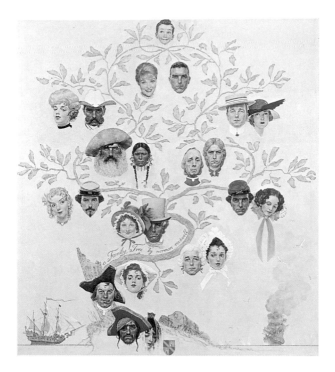

FAMILY TREE

Post Cover • October 24, 1959

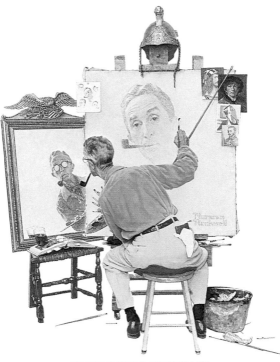

TRIPLE SELF PORTRAIT

Post Cover • February 13, 1960

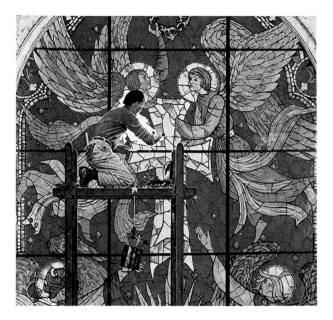

STAINED GLASS
Post Cover • April 16, 1960

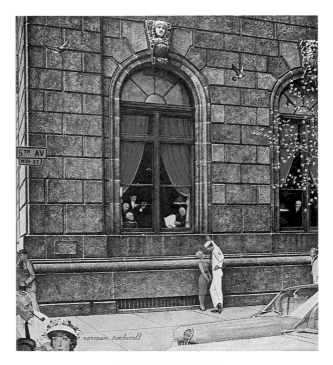

UNIVERSITY CLUB

Post Cover • August 27, 1960

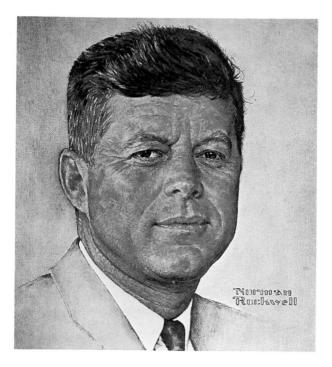

JOHN F. KENNEDY
Post Cover • October 29, 1960

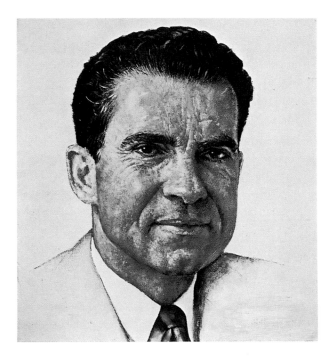

RICHARD M. NIXON

Post Cover • *November 5, 1960*

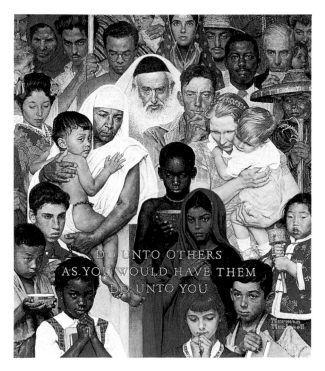

DO UNTO OTHERS

Post Cover • April 1, 1961

NEW LOGO

Post Cover • September 16, 1961

CHEERLEADER

Post Cover • *November 25, 1961*

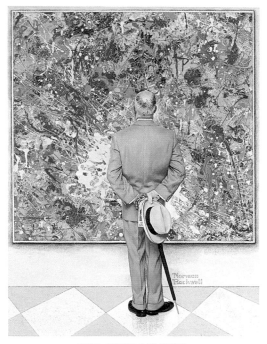

THE CONNOISSEUR

Post Cover • January 13, 1962

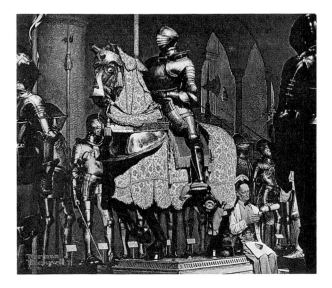

LUNCH BREAK

Post Cover • *November 3, 1962*

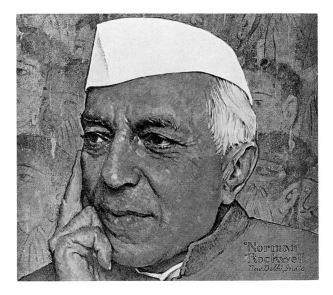

JAWAHARLAL NEHRU

Post Cover • January 19, 1963

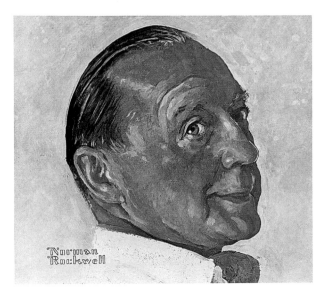

JACK BENNY

Post Cover • March 2, 1963

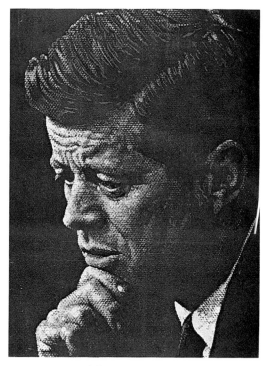

JOHN F. KENNEDY

Post Cover • *April 6, 1963*

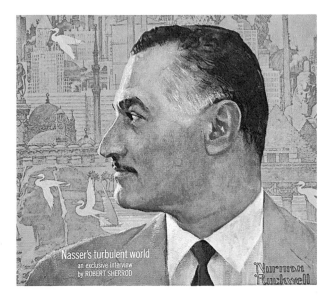

Nasser's turbulent world
an exclusive interview
by ROBERT SHERROD

Norman Rockwell

GAMAL ABDAL NASSER

Post Cover • May 25, 1963

SELECTED **TINY FOLIOS**™ FROM ABBEVILLE PRESS

American Art of the 20th Century: Treasures of the Whitney
 Museum of American Art 978-0-7892-0263-5 ▪ $11.95

American Impressionism 978-0-7892-0612-1 ▪ $11.95

Audubon's Birds of America: The Audubon Society
 Baby Elephant Folio 978-0-7892-0814-9 ▪ $12.95

The Great Book of Currier & Ives' America
 978-1-55859-229-2 ▪ $11.95

The Great Book of French Impressionism
 978-0-7892-0405-9 ▪ $11.95

The North American Indian Portfolios: Bodmer, Catlin,
 McKenney & Hall 978-0-7892-0906-1 ▪ $11.95

Treasures of British Art: Tate Gallery 978-0-7892-0541-4 ▪ $11.95

Treasures of Impressionism and Post-Impressionism:
 National Gallery of Art 978-0-7892-0491-2 ▪ $11.95

Treasures of the Louvre 978-0-7892-0406-6 ▪ $11.95

Treasures of the Museum of Fine Arts, Boston
 978-0-7892-0506-3 ▪ $11.95

Treasures of 19th- and 20th-Century Painting: The Art Institute
 of Chicago 978-0-7892-0402-8 ▪ $11.95

Treasures of the National Gallery, London 978-0-7892-0482-0 ▪ $11.95

Treasures of the National Museum of the American Indian
 978-0-7892-0841-5 ▪ $11.95

Treasures of the Uffizi 978-0-7892-0575-9 ▪ $11.95

Women Artists: The National Museum of Women in the Arts
 978-0-7892-1053-1 ▪ $11.95